SONY® α500 α550

Peter K. Burian

D1236121

MAGIC LANTERN GUIDES®

SONY®
α500 α550

Peter K. Burian

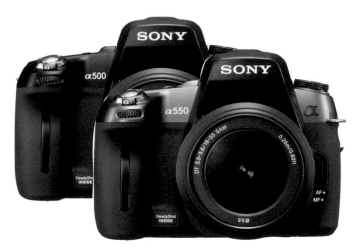

LARK
PHOTOGRAPHY
BOOKS

A Division of Sterling Publishing Co., Inc.
New York / London

Editor: Matt Paden, Kara Arndt
Book Design: Michael Robertson
Cover Design: Thom Gaines

Burian, Peter K.
 Sony A500/A550 / Peter K. Burian. -- 1st ed.
 p. cm. -- (Magic lantern guides)
 Includes index.
 ISBN 978-1-60059-693-3
 1. Sony digital cameras--Handbooks, manuals, etc. 2. Single-lens reflex cameras--Handbooks,
manuals, etc. I. Title.
 TR263.S66B8636 2009
 771.3'2--dc22
 2009039578
 10 9 8 7 6 5 4 3 2 1

First Edition

Published by Lark Books, A Division of
Sterling Publishing Co., Inc.
387 Park Avenue South, New York, N.Y. 10016

Text © 2010, Peter K. Burian
Photography © 2010, Peter K. Burian, unless otherwise specified

Distributed in Canada by Sterling Publishing,
c/o Canadian Manda Group, 165 Dufferin Street
Toronto, Ontario, Canada M6K 3H6

Distributed in the United Kingdom by GMC Distribution Services,
Castle Place, 166 High Street, Lewes, East Sussex, England BN7 1XU

Distributed in Australia by Capricorn Link (Australia) Pty Ltd.,
P.O. Box 704, Windsor, NSW 2756 Australia

This book is not sponsored by Sony, Inc.

If you have questions or comments about this book, please contact:
Lark Books
67 Broadway
Asheville, NC 28801
(828) 253-0467

Manufactured in Canada

ISBN 10: 1-60059-693-3

For information about custom editions, special sales, premium and corporate purchases, please
contact Sterling Special Sales Department at 800-805-5489 or specialsales@sterlingpub.com. For
information about desk and examination copies available to college and university professors,
requests must be submitted to academic@larkbooks.com. Our complete policy can be found at www.
larkbooks.com.

Contents

Understanding Digital Photography

THE SONY-KONICA MINOLTA CONNECTION

In July 2005, Konica Minolta and Sony issued a press release indicating an agreement to jointly develop digital single-lens-reflex (D-SLR) cameras using technology to be provided by both companies. Then, in January 2006, Konica Minolta announced that it would withdraw from the photo products market and transfer some of its assets to Sony. Subsequently, Sony developed its own D-SLR cameras, employing the most valuable features from the Maxxum/Dynax D-SLRs plus sophisticated Sony technology, as well as some new amenities.

Since that time, Sony has developed many new D-SLR cameras with the Alpha α logo. Most of those models are covered in other Magic Lantern Guide books. The α500 and α550 were announced in August 2009 and this duo boasts some entirely new features not available with earlier Sony cameras. Both are compatible with all Sony Alpha accessories and lenses, including the Carl Zeiss ZA (Zeiss Alpha) series. You will also find you can use most Maxxum/Dynax lenses and accessories, including the latest flash units.

DIFFERENCES BETWEEN DIGITAL AND FILM PHOTOGRAPHY

Not very long ago it was easy to tell the difference between photos taken with a digital camera and those shot with a traditional film camera: pictures from digital cameras didn't have the same quality as those from film. However, this is no longer true. With the α500 and the α550, you can make 13 x 19-inch (33 x 48 cm) prints that look as good, or better, than an enlargement from a 35mm negative. When made from your technically best images, even larger prints can be suitable for framing.

Whether digital or film-based, a camera is basically a light-tight box that uses a lens to focus the image. You regulate the amount of light entering this box to strike the light-sensitive medium (film or sensor) by adjusting the aperture (f/stop) or the shutter speed. However, in traditional photography the image is recorded on film and later developed with chemicals, while in digital photography the camera converts the light to an electronic image. A digital camera immediately processes this image internally and stores it temporarily on a memory card for downloading, while a film camera stores the exposed film for processing at a later time. While many exposure techniques remain the same, digital photography will help you take advantage of a number of enjoyable and creative possibilities available with this new technology.

THE DIGITAL SENSOR VS. FILM

Both film and digital cameras expose pictures in nearly identical fashion. The light measuring (metering) methods are the same, both work with ISO-based systems, and the shutter and aperture mechanisms controlling the amount of light admitted into the camera are the same. These similarities exist because both film and digital cameras share the same goal: to deliver the appropriate amount of light required by the film or sensor to create a good picture.

Not surprisingly, however, digital sensors respond differently to light than film does. From dark areas (such as navy blue blazers, asphalt, and shadows) to mid-tones (blue sky and green grass) to bright areas (such as white houses and sand beaches), a digital sensor responds to the full range of light equally, or linearly. Film, however, responds linearly only to mid-tones (those blue skies and green fairways). Therefore, negative

film blends tones very well in highlight areas and slide film blends tones well in shadow areas, whereas digital sensors often cut out the bright tones. Digital responds to highlights like slide film and to shadows like negative film.

MEMORY CARDS VS. FILM

Memory cards are necessary to store images captured by a digital camera. These removable, reusable cards offer several advantages over film. They can store more photos, are smaller than rolls of film, and offer greater image permanence.

The latent image (exposed but undeveloped film) is susceptible to degradation from atmospheric conditions such as heat and humidity. And new security monitors for packed and carry-on luggage can also damage film. Traveling photographers find that digital photography allows them much more peace of mind. Not only are memory cards more durable, but their images can also be easily downloaded into storage devices or laptops. No more concerns over what to do with precious exposed film!

THE LCD MONITOR

In conventional film photography, you are never really sure your picture is a success until the film is developed. You must wait to find out if the exposure was correct or if something happened to spoil the results, such as the blurring of a moving subject or unwanted stray reflections from an on-camera flash.

When using a D-SLR, however, you can see an image on the LCD monitor almost immediately after taking a picture. Admittedly, you cannot see all the details that you would see in a print, but this ability means that you can evaluate the picture you have just shot. If the exposure, lighting, or composition is not quite right, simply re-shoot on the spot. This feature is especially useful in flash photography. In addition to confirming correct exposure, the LCD monitor allows you to check for any excessively bright highlight areas or dark backgrounds, as well as allowing you to evaluate other factors, such as the effect produced by multiple flash units and/or reflectors. Specifics about the LCD monitor on the α500 and α550 will be covered in chapter 2.

EXPOSURE AND THE HISTOGRAM

Digital cameras do not offer magic tricks that let you beat the laws of physics, so incorrect exposure will still cause problems. Too little light makes dark images; too much light makes overly bright images. Granted, you can correct digital images to a certain extent afterwards by using software in a computer, but programs can't recreate blown details that never existed in overexposed images. Getting the correct exposure in-camera can save you a great deal of post-processing work.

After you shoot a digital image, a quick glance at the LCD monitor will indicate whether the exposure (image brightness) is close to accurate. Better yet, you can also access a feature that provides a more scientific evaluation of brightness values: the histogram (see page 145 for details). Because you are able to check exposure using these scales, there is less need to bracket (shoot a series of images at different exposure levels) when using the α500 or the α550 than with a traditional film camera.

ISO (SENSITIVITY)

Digital sensors don't have a true ISO. However, their sensitivity has been adjusted electronically to mimic film ISOs. Hence, you can set the ISO to 200 for average daylight shooting, 800 for faster shutter speeds or smaller apertures in less bright situations, or 1600—and even ISO 3200—for lowlight photography. With a digital camera, you can change ISO from picture to picture—it's like changing film at the touch of a button! This provides certain benefits, such as the ability to first shoot indoors without flash at ISO 800, then follow your subject outside into bright sun and optimize image quality by switching immediately to ISO 200.

NOISE/GRAIN

Grain in film appears as an irregular, sand-like texture that, if large, can be unsightly and, if small, is essentially invisible. (A textured look is sometimes desirable for certain creative effects.) It occurs due to the chemical structure of the light sensitive materials and is most prominent in fast films, such as ISO 1600.

The equivalent of grain in digital photography is known as noise, which often occurs as colored specks most visible in dark or evenly-colored mid-tone areas. Digital noise occurs for several reasons: sensor noise (caused by heat from the electronics and optics), digital artifacts

∧ The camera automatically applies Noise Reduction processing at very high ISO levels but for the "cleanest" images, avoid underexposure.

(when digital technology cannot deal with fine tonalities such as sky gradations), and JPEG artifacts (caused by image compression). Sensor noise is the most common.

Although the α500 and the α550 provide extra noise reduction processing at high ISO levels, digital noise is most prominent in images made at high ISO settings (especially at ISO 1600 or higher), and will increase as the ISO increases.

The mottled colored specks are even more obvious in images that are underexposed and lightened afterward in image processing software. You can buy third-party software for further noise reduction, but it's best to use ISO 400 or lower when practical for the absolutely "cleanest" images.

Sensor noise may also increase when using very long exposures under low-light conditions, as in night photography. However, the camera's long exposure noise reduction feature applies additional processing is applied to minimize the digital noise pattern. In most situations, the α500 and the α550 produce images with very little digital noise at ISO settings up to 1600 and acceptable digital noise at ISO 3200.

FILE FORMATS

A digital camera converts analog image information to digital data and records a digital file. The α500 and the α550 offer two distinct file formats: JPEG and RAW. They also offer another option: RAW + JPEG, which records each photo in both the RAW and the JPEG (Fine quality and Large size) formats simultaneously.

JPEG: An acronym for Joint Photographic Experts Group, JPEG is the most common format in digital photography, and is actually a standard for compressing images rather than a true file format. Digital cameras use JPEG because its compression reduces file size, allowing more pictures to fit on a memory card.

RAW: A generic term for a format that has little or no internal processing applied by the camera. Most camera manufacturers have developed proprietary versions of RAW. Sony's version is denoted in image files with the suffix "ARW" but I will often refer to ARW files with the generic term RAW.

RESOLUTION

Resolution refers to the quantity of pixels being utilized: 12.3 million with the α500 and 14.2 million with the α550. Virtually all of today's digital cameras give you choices about how many of the sensor's pixels to use when shooting pictures. In other words, you do not always need to employ the camera's maximum resolution. Your memory card will hold more images when the camera is set to record at lower resolutions, but it will not capture as much data; and the more digital information (higher resolution), the bigger the print it is possible to make.

WHITE BALANCE

Most pros who have shot film over the years can tell you about the challenges of balancing their light source with the film's response to the color of light. For example, daylight-balanced (outdoor) film used indoors under tungsten household lamps will produce pictures with an orange cast. Accurate color reproduction in this instance would require the use of a blue color-correction filter.

^ Selecting a white balance setting to match the shooting conditions will make colors appear more natural. Here, the Cloudy WB setting was used on an overcast day to get a pleasing color balance.

The color of light also varies in other circumstances, though our eyes and brain make natural adjustments so we do not notice this variation. Light is quite blue on an overcast day, even bluer in a shady area, green under fluorescent lighting, orange under tungsten lamps, and so on. In film photography, filters attached to the front of a lens can correct for the color cast by altering the color of the light so our subjects are rendered as we normally see them.

This has changed with digital cameras. Color correction is managed by the built-in white balance functions. The camera can automatically check the light, calculate the proper setting for its color temperature, and make the necessary modification. This automated system is programmed to produce pictures without color casts or inaccurate tones. However, this system is not foolproof, so user-selectable white balance options (for specific types of lighting) and other overrides are also provided.

Features and Functions

The α500 and the α550 are versatile enthusiast-level models with some technology not available in other cameras in the same class. While they are easy to use for those who are new to D-SLRs, the cameras will also satisfy some experienced photographers thanks to their many advanced capabilities. In this chapter we'll review the few differences between the models, do a quick run-down of the features and specs these cameras offer, and then go into a bit more depth about some important features you'll want to be familiar with before shooting. This chapter also offers a quick-start guide if you want to jump right into taking pictures.

MODEL DIFFERENCES

The two cameras are virtually identical, especially physically—both are finished with a scratch-resistant matte exterior over a strong metal chassis. However, they do differ in three important aspects, as follows. The differences and concepts will be discussed in more detail later in this chapter. As well, they will be mentioned whenever appropriate throughout this guidebook to prevent any confusion as to the specifications for either camera.

Resolution: The α550 employs a 14.2 megapixel (MP) sensor for image capture while the more affordable α500 uses a 12.3 megapixel (MP) sensor. Hence, the resolution differs.

LCD: Both cameras are equipped with a 3-inch (7.62 cm) variable-angle screen. The Xtra Fine LCD on the α550 provides unusually high 921,600 dot resolution, while the Clear Photo Plus LCD on the α500 offers a more typical (yet still high) 230,400 dot resolution.

Speed: In Continuous mode, both cameras can take a series of photos at the same 5 frame-per-second rate, but only the α550 offers a unique new feature: Speed Priority with a 7 frame-per-second advance rate.

TECHNICAL ASPECTS

The α500 and α550 are technically advanced, providing a wealth of features to be discussed in detail throughout this book. They capture images using a new Exmor CMOS (Complementary Metal Oxide Sensor) chip with on-chip noise reduction.

The data is processed by a powerful BIONZ engine with Large Scale Integrated circuitry for high speed. That allows for shooting a series of photos at 5 frames per second (fps); when Live View is active, the continuous rate is 4 fps. The α550 is particularly fast, when used in its unique Speed Priority mode (discussed in detail on page 119). Even after taking a burst of photos, the cameras are usually ready for more shots. To ensure that they can take the greatest possible number of shots in a series—and for fast downloading of large image files to a computer— use a high-speed SDHC card, rated at 133x or Class 6, or the very fast Memory Stick PRO-HG Duo HX.

> © Sony

OVERVIEW AND SPECS

The following information is provided for easy reference to the features and specifications your Sony camera offers. Refer to these lists to quickly learn more about the α500 and α550 and what they have to offer, or whenever you are looking for specific information regarding your camera.

OVERVIEW OF FEATURES

Though compact, the α500 and α550 are well-equipped cameras with many automatic, semi-automatic, and manual options. They are easy to use in point-and-shoot modes, but highly suitable for serious photography due to their versatility. Let's take a quick look at the most significant aspects of both cameras.

O The α500 is equipped with a 12.3MP (effective) sensor to make images with a maximum resolution of 4272 x 2848 pixels. The α550 employs a 14.6MP (effective) sensor with 4592 x 3056 pixels in the standard 4:3 aspect ratio. Both cameras can be set to a 16:9 aspect ratio format for making images of the same "shape" as a widescreen HD TV at a maximum of 4272 x 2400 pixels and 4592 x 2576 pixels, respectively.

O Although the cameras generate large image files, they can shoot at 5 frames per second (fps) when the Continuous drive mode is selected. Do note, however, that the framing rate slows to 4 fps when Live View is active. The α550 also offers a Speed Priority mode (when the optical viewfinder is used) with 7 fps advance; focus and exposure are locked at the first frame, making this feature most useful for a subject that does not move to a different distance from the camera, and in lighting that does not change.

O A 3-inch variable-angle LCD monitor provides a clear, crisp display of data and images. A Graphic Display on-screen interface provides an intuitive indication of how shutter speed and aperture adjustment will affect the final image. A Help Guide provides information about camera modes and functions.

O Live View provides a real-time preview of the scene on the LCD screen before a photo is taken. The display shows 90% of the full image area. The primary mode is Quick AF Live View with Face Detection and Smile Shutter, if those functions are activated. (Face Detection optimizes focus, exposure, and White Balance for faces in the scene; Smile Shutter technology automatically takes a shot when your subject smiles.)

O The cameras are equipped with a 9-point focus detection sensor and continuous-tracking focus technology that can track the motion of a moving subject; both work whether you use the optical viewfinder or Quick AF Live View mode.

O A second live preview option is available too. The entirely new Manual Focus Check Live View provides a 100% view of the image area with a crisper, less grainy preview image for checking focus and composition. In this second mode, autofocus is not available, but temporary 7x or 14x magnification can be set making it easier to confirm critical focus. This feature is most useful in extremely close focusing (macro) and when the camera is mounted on a tripod.

O A Smart Teleconverter option is available—but only while the camera is in Quick AF Live View mode and set to JPEG capture. This option instantly boosts image size by 1.4x or 2x to extend your camera's zoom lens for a more frame-filling close-up photo; full image quality is maintained.

O An improved version of the sophisticated BIONZ processing engine minimizes digital noise (graininess) at high ISO levels. This allowed Sony to provide sensitivity options up to ISO 12800 for low light photography without flash or a tripod.

O Sony's proprietary Dynamic Range Optimizer (also abbreviated as D-Range Optimizer or DRO) employs special processing to optimize images for increased shadow detail; five intensity levels are available. In practical terms, the DRO system can lighten dark areas without making highlight areas too bright and while retaining snappy contrast; this can be a definite benefit under high-contrast lighting.

O A unique new feature, Auto HDR (High Dynamic Range) is available. When set, this allows for shooting two photos (while hand-holding the camera, if desired) at different exposure levels; the camera's processor then combines them into a single image with maximum highlight and shadow detail.

O Sony's SteadyShot system compensates for camera shake by shifting the CMOS sensor. This device stabilizes most Maxxum/Dynax and all Sony and Carl Zeiss ZA (Zeiss Alpha) lenses, providing an advantage of up to four shutter speed stops over non-stabilized cameras/lenses.

O Anti-Dust technology includes a static-free coating on the filter over the CMOS sensor to help repel dust; when you turn the camera off, the sensor is vibrated in order to dislodge any dust particles.

> Thanks to Sony's SteadyShot image stabilizer, it's easier to get sharp images without using a tripod at slower shutter speeds.

O The high-capacity rechargeable NP-FM500H battery is rated to provide up to 1000 shots on a single charge with the α500 (520 shots in Live View) and 950 shots with the α550 (480 in Live View), assuming 50% flash usage (CIPA Standard). The cameras provide an accurate display of power remaining in percentage increments. Use of the optional VG-B50AM Vertical Control Grip with two of the batteries will double the number of shots you can take before recharging.

O When you use an optional HDMI cable, you can connect either camera to a wide screen HD television and view images on the memory card in high definition. If you own a recent Sony Bravia television with a PhotoTV HD feature, the images will be automatically optimized for better detail, color, and clarity.

SPECIFICATIONS

Image Sensor: Exmor CMOS (approximately 23.5 x 15.6 mm) with RGB filter array and low-pass filter; Anti-Dust features; 1.5x field-of-view crop

Maximum Resolution: α500: 12.3 million recording pixels; α550: 14.2 million recording pixels

Image Size Options: Large, Medium, and Small selectable in 3:2 format and 6:9 format; resolution is lower when Medium and Small are set

Image Sizes:
α500: 4272 x 2848 (L), 3104 x 2072 (M), 2128 x 1416 (S) in 3:2 mode; 4272 x 2400 (L), 3104 x 1744 (M), 2188 x 1192 (S) in 16:9 mode
α550: 4592 x 3056 (L), 3344 x 2224 (M), 2288 x 1520 (S) in 3:2 mode; 4592 x 2576 (L), 3344 x 1872 (M), 2288 x 1280 (S) in 16:9 mode

Quality: JPEG Fine and JPEG Standard; RAW (ARW format); RAW+JPEG Fine and RAW+JPEG Standard options

Sensitivity: ISO 200 to 12800 selectable; also, Auto ISO (ISO 200-1600 range)

Viewfinder: 95% field of view; 0.80x magnification; Spherical Acute Matte focusing screen; diopter correction, -2.5 to +1; removable eyepiece cup; info display in viewfinder; Eye-Start sensors

LCD: Vertically tiltable 3-inch (7.62 cm) screen with 100% scene coverage and ambient light sensor for brightness boosting in bright light; the α500 employs a 230,000 dot Clear Photo LCD Plus; the α550 employs a 921,000 dot Xtra Fine LCD; Graphic Display interface and Help function

Autofocus: 9-point focus detection system; automatic focus point selection; any single point is selectable; Single-shot AF (AF-S), Auto AF mode selection (AF-A), and Continuous predictive tracking (AF-C); AF illuminator with flash; Manual focus selectable

Live View: Two modes, Quick AF Live View (with available Face Detection and Smile Shutter if desired) and Manual Focus Check Live View with selectable 7x/14x magnification

Image Stabilizer: SteadyShot sensor-shift system

Drive Modes: Single-shot, Continuous Low, and Continuous High speed (to 5 fps; 4 fps in Live View), Self-timer, Exposure Bracketing, WB Bracketing, and Remote Commanders; Speed Priority with α550 only (7 fps)

Shutter Speeds: 30 to 1/4000 sec. plus Bulb; top flash sync speed 1/160 sec.

Exposure Modes: AUTO and Auto/Flash Off, Program (shiftable), Aperture and Shutter Priority AE, Manual, plus seven scene modes (Portrait, Landscape, Macro, Sports Action, Sunset, Night View/Portrait)

Autofocus System: 9-point sensor with cross hatched central point; Wide area AF (9-point, automatic point selection), Spot (central point only) and Local (select any single point); Single shot (AF-S), Continuous predictive tracking (AF-C), and auto switching between AF modes (AF-A); focus-assist with flash; Eye-Start AF activation

Exposure Metering: Center weighted, Spot, and 40-segment honeycomb pattern (evaluative); 1200-segment evaluative metering in Quick Auto Focus Live View mode; exposure compensation and Bracketing; AE Lock; also, Dynamic Range Optimizer (Auto and five user-selectable levels) plus Auto HDR

White Balance: Automatic, Daylight, Shade, Cloudy, Incandescent, Fluorescent, Flash, Color Temp, and Custom WB; also Color Filter and WB fine-tuning

Creative Styles: Standard, Vivid, Portrait, Landscape, Sunset, and B&W; adjustments for Contrast, Saturation, Sharpness

Color Space: sRGB or Adobe RGB selectable

Noise Reduction: High ISO NR (at ISO 1600 and above) with levels selection; Long Exposure NR (at 1 sec. and longer exposures) with On/ Off control

Flash: Built-in, with automatic pop-up in some Scene modes and manual "up" control; pre-flash TTL; ADI flash metering with Maxxum D-series and Sony or Carl Zeiss ZA lenses; Flash Exposure Compensation and Bracketing available; Fill-flash, Flash cancel, Slow Sync, and Rear Curtain Sync modes; Auto, Fill Flash, Slow Sync, Rear Sync modes, and Wireless (wireless off-camera TTL flash control with certain optional flash units); high-speed sync available with some optional flash units

Power: One NP-FM500H Lithium-Ion rechargeable battery (1650 mAh); optional AC adapter; also, optional battery pack/vertical grip VG-B50AM for use with one or two NP-FM500H batteries

Recording Media: Memory Stick Pro DUO series and SD or SDHC cards; mechanical switch for card type selection

Connectivity: USB 2.0 high-speed; HDMI out (with optional cable); DC-in (for AC adapter AC-PW10AM), and a socket for the remote control accessory

Dimensions/Weight: 5.4 x 4.1 x 3.3 inches (137 x 104 x 84mm) W/H/D; 21.1 oz. (597 g) without battery

Other Features: Orientation sensor for LCD data and images; USB 2.0 High-speed output; Smart Teleconverter; histogram in Live View and Playback available; Function sub-menu; Grid Line Display

Software Supplied: Picture Motion Browser, Image Data Converter SR 3.1, Image Data Lightbox SR in North America; software suite may vary by geographic region

Optional Accessories: Sony, Carl Zeiss ZA, and Maxxum/Dynax AF lenses; compatible with Maxxum/Dynax D-series flash units and Sony HVL flash units; accepts Sony Alpha accessories, including the VG-B50AM vertical grip and wired remote controller RM-S1AM or RM-L1AM, plus certain Maxxum/Dynax accessories

Before moving on to additional specifics about the technology and features of these Sony cameras, you may want to take some photos. Here's how you can do so, step-by-step.

o Mount a lens and install a fully charged battery; insert a Memory Stick Pro DUO, an SD, or SDHC memory card into the suitable (well marked) slot under the door in the handgrip. (Open that door by applying light pressure to it and pulling it toward you.) Make sure the small switch is set to SD if you're using an SD or SDHC card.

o Turn the camera on with the power switch around the shutter release button.

o Find the AF/MF switch on the front of the camera (below the lens release button) and shift it to the AF position to ensure that the camera will provide autofocus. If you're using a Sony or Maxxum/Dynax lens that is equipped with its own AF/MF switch, you can use that control instead of the switch on the camera body.

o To make sure that the α500 or α550 is at the factory-set defaults, press the Menu button, and scroll to Setup menu ↘ 3 with the four-way controller's right key. Scroll down to the Reset default item and press the AF button (in the center of the controller) to confirm your decision.

o If you simply want to take quick snapshots, rotate the mode selector dial to AUTO or to one of the Scene mode icons, such as Portrait 🔲 for people pictures; you can then simply point and shoot.

o Note the Live View/OVF switch on the camera's right shoulder. Set this to Live View and you can compose photos on the large LCD screen on the camera back. If you prefer to use the optical viewfinder, set the switch to the OVF position.

o Point the lens at a subject, and the camera's Eye Control system will activate the autofocus system and set focus; press the shutter release button to take the photo when you're ready. Almost instantly afterwards, the photo will be visible in the LCD monitor.

o In AUTO and most of the Scene modes the camera will pop up the built-in flash in low light and fire it when necessary.

o To view all of the photos you have taken, press the ▶ button and scroll through images with the left/right keys of the four-way controller.

o After you are finished taking photos, you can attach the camera to a computer with the USB cable (included) or remove the memory card and insert it into a memory card reader accessory (see page 183).

NOTE: By default, the camera is set to shoot large JPEGs (with maximum resolution) at the Fine (best) quality level; this is the most frequently used combination and allows the camera to provide excellent image quality. It is not advised to change from this setting unless you specifically want to shoot lower quality images or shoot in RAW, or RAW+JPEG (see page 58).

∧ Learning to use the various exposure modes on your Sony camera will allow you to take better pictures. Here, the Shutter Priority mode (S) was selected making it simple to select the desired long shutter speed.

ADVANCED PICTURE-TAKING

Experienced photographers will want to start by using one of the more advanced modes, although some of the information in the previous section can be useful for the basic setup. Try using Aperture Priority (A) for example, to select f/stops by rotating the control dial just below the On/Off switch; the camera will set an appropriate shutter speed for a good exposure. Using these P, A, S, and M modes, which will be discussed in more detail in chapter 5, allow for much more creative variety in your picture taking. Below are some other considerations to get started with some of the cameras' user-selectable features once you progress beyond the Auto mode.

NOTE: In the P, A, S, and M modes the flash will never pop up automatically; if you raise it (by pressing the ⚡ button on the left side of the pentaprism), the flash will fire for every shot, regardless of the lighting conditions.

Drive mode: If you want to shoot a series of images in a burst, press the Drive button ⏱/🖳, scroll to the 🖳Hi option (5 frames per second or 4 fps in Live View) and press the AF button to confirm your selection. By default, the Autofocus mode is set to AF-A: automatic switching into continuous tracking focus, should the subject begin to move toward the camera or away from your position. This is a useful multi-purpose setting; however, for sports photography, set it to Continuous AF (AF-C) for even greater autofocus reliability. By default, the AF Area function is set to Wide ⌐ ⌐, so the camera can focus on a small subject even if it's off-center; again, this is useful for most picture taking.

HINT: When the camera is set for Quick AF Live View, Face Detection 📷ON autofocus (discussed in the previous section) is set to On by default. If you will not be taking people pictures, turn it off in the pertinent menu under the 🔲 button's sub-menu; that will make autofocus faster, since the system will not try searching for faces.

ISO: Check the ISO by pressing the ISO button on top of the camera and you'll note that it's set for Auto; the camera will set an ISO from 200 in bright light to 1600 in a dark location; the higher the ISO, the faster the shutter speed will be at any aperture that you set. Experienced photographers will want to set their own ISO levels by scrolling to the desired option and pressing the AF button.

Metering: The Metering mode is set to Multi segment, the intelligent evaluative metering pattern; this is an ideal choice for most photography. If you want a brighter or darker photo, press and hold the exposure compensation 🔲 button; rotate the control dial to set plus or minus compensation. (You will rarely need to use minus compensation; when plus compensation is necessary, for a brighter photo, you'll rarely need to use more than +1.)

🅵🅽 button: Press the 🅵🅽 button to reveal a sub-menu of frequently used functions. Scroll to any item and press the AF button in the controller to reveal the available options. With some of the functions, scrolling to the right will reveal additional options. (Note that ISO, Drive Mode, and DRO (Dynamic Range Optimizer) can also be accessed with well-marked buttons on the camera's right shoulder.)

Scroll down to AWB (Auto White Balance); check out the other options here for providing better overall color balance under specific types of lighting. White balance is discussed in greater depth on page 60.

Scroll to the DRO Auto 🄳🅁🄾 item in the 🅵🅽 sub-menu and you can set the Dynamic Range Optimizer as desired for greater shadow detail in harsh lighting. Scroll to the right from 🄳🅁🄾 and set the intensity to Lv2; that's a suitable level when first experimenting with this feature. An HDR Auto 🄷🄳🅁 feature is also available but this is a unique function that will be discussed later (on page 77).

Access the Creative Style item in the 🅵🅽 menu and you'll find that you can instruct the camera to produce a photo of a desired style, such as ⎡Vivid⫯ (with very rich colors), ⎡Portrait⫯ (optimized for natural skin tones and moderate contrast), and ⎡Landscape⫯ (for especially vivid blues and greens). Scroll to the right from any of these styles and you can set a desired level for Contrast ◑, Color Saturation ❸, and Sharpness ⫐. Initially, do not make any settings for these three items until you are more familiar with the effect that the camera produces without overrides.

HINT: Use Live View while experimenting with White Balance, Creative Styles, Exposure Compensation, and DRO. Point the camera at a colorful subject. Make changes in settings slowly and you'll see that the preview display changes to reflect the effect that each option will provide. The display is not 100% accurate in this respect and it does not change instantly to reflect the effect of a new setting, but this preview can be somewhat useful.

GETTING TO KNOW THE α500 & α550

Since we are taking this chapter to learn about the basics of the α500 and α550, let's now take a more in-depth look at some of the features and functions you will likely use most often. This list includes both physical features and picture-taking options that you'll want to have a general understanding of before diving more deeply into your camera.

Spend time with your camera, getting to know it well. Become familiar with each of the controls. Many of the abbreviations and icons used to denote the various features are common to other digital cameras, so they may already be familiar. Some are intuitive; for example, WB stands for white balance; AF/MF denotes autofocus/manual focus; AEL stands for auto exposure lock, and so on.

QUICK-START FEATURES

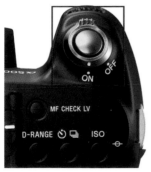

© Sony

POWER SWITCH

The main power switch for the camera is located on the top of the camera, around the shutter button.

POWER SAVE

The α500 or α550 will go into power saving "sleep mode" if it is on but has not been operated for a given length of time; the default is 20 seconds if the camera is in Live View and 10 seconds if it's set for using the optical viewfinder, but longer periods can be set in Setup menu ⚒ 1. If the camera is in power saving mode, simply touch the shutter button to reactivate it.

MEMORY CARD FEATURES

The α500 and α550 accept two distinct types of memory cards (see page 183). You can insert two cards at one time. Simply set the switch inside the memory card chamber to the SD position when you want to use the SD or SDHC card or the Memory Stick logo if you want to use the Memory Stick DUO card. When one card fills up, simply switch to using the other card; it takes only a few seconds to flip the card type switch.

NOTE: Be sure to format any card you use in the camera and not with a computer or other device. That will prevent compatibility problems. (The formatting procedure, discussed on page 93, deletes every bit of data so make sure to first save any images on the card to a computer or other device.) Do not remove a card or flip the switch to change to using the other card while the red lamp (at the top of the card door) is lit; if you do so, there will be some loss of data and the card may become corrupted.

RESETTING CONTROLS

Once you become familiar with your α500 or α550 you are likely to change settings often. After experimenting extensively, you may want to quickly return to the original default settings. To do so, use the [Reset Default] option in Setup menu ⚒ 3; see page 100 for more details.

EXTERNAL PORTS

Both cameras feature several terminals for attaching accessories. Note the two long rectangular ports on the left side of the body, covered with rubber doors. The smaller door marked REMOTE hides the port for an optional remote controller unit, the RM-S1AM or the longer RM-L1AM; either can be used to remotely trigger the shutter without jarring the camera, which helps to eliminate vibration during long exposures.

©Sony

Open the longer door to reveal two ports. The USB cable included in the camera kit connects the camera to a computer's USB port ⟿ for downloading image files, or to some recent PictBridge compatible printers for printing directly from the camera. If your wide-screen HD television is equipped with a port marked ⟿, you can connect the camera to the TV with the USB cable.

The HDMI port accepts an optional HDMI Min (type C) cable for connecting the camera to the HDMI input port that's common on wide-screen HD TV sets; that allows for displaying images in high definition on a much larger screen.

NOTE: No cable is provided for connecting the camera to a television monitor's conventional video-in port. You may be able to buy a third-party cable for this purpose. A cable of this type should have a plug that will fit into the camera's small USB port while the other end should have so-called RCA plugs; you would plug only the yellow plug into the television's video-in port. Do note however that the USB port on the α500 and α550 is not identical to the USB port of many other cameras; it's essential that any accessory cable with RCA plugs be designed specifically to fit the camera's USB port.

On the right side of the camera, above the memory card door, you'll find a small door marked DC IN that hides the port for an optional Sony AC adapter that can be used instead of the battery for powering the camera. Use only the AC-PW10AM device sold in your geographic region.

©Sony

NOTE: In order to prevent causing a serious camera malfunction, do not use any other device to power the camera.

^ Use the mode dial to select an exposure mode for creative photography. In this image, Shutter priority mode (S) was used making it simple and quick to set a fast shutter speed.

CAMERA CONTROLS

Let's now take a look at the analog controls that are used to navigate and manage camera functions.

THE MODE DIAL

Located on the camera's top left shoulder, this dial is used for selecting the exposure mode. The abbreviations P, A, S, and M denote the following modes: P for Program (shiftable, so you can change the aperture/ shutter speed combination), A for Aperture Priority (semi-automatic; camera chooses the shutter speed), S for Shutter Priority (semi-automatic; camera chooses the aperture),

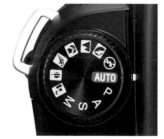

©Sony

and Manual (for manual selection of both aperture and shutter speed using guidance from the camera's light meter, but without automation).

The **AUTO** mode is fully automatic (no aperture/shutter speed shift available), while the picture icons denote the various Scene modes: Auto with Flash off ⚡, Portrait 👤, Landscape 🏔, Macro (close-up) 🌷, Sports Action 🏃, Sunset 🌅 and Night Portrait/Night View 🌃. Each was designed to produce good photos with the specific type of scene or subject.

CONTROLLER

©Sony

This circular pad on the back of the camera has four arrow keys that allow you to scroll up, down, right, and left. (That's why it's also called the four-way controller.) The button in the center of the pad is marked AF but it's often used as an OK button to confirm a selection in the electronic menu or in the Function sub-menu. It's marked AF because it has another function when autofocus is active: setting the Spot AF area—the central focus detection point—as discussed in the Camera and Shooting Operations chapter.

Fn *BUTTON*

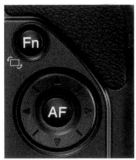

©Sony

Located above the Controller, the Function button **Fn** activates a sub-menu for access to specific functions and the options for each of them (as discussed earlier, on page 32). While experimenting, set the camera to P, A, S, or M mode; in the Scene modes, only a few items are available in the Function sub-menu.

ADDITIONAL BUTTONS

A quick check of the camera will indicate that three of the features available in the Function sub-menu can also be accessed with external buttons—D-RANGE (also called DRO), Drive mode ♦/➡,and ISO. Some experienced photographers may prefer to use these buttons for setting any of those three features. After pressing the pertinent button, scroll through the options with the keys of the four-way controller or the camera's control dial; after making a change, press the AF button in the controller to confirm your selection.

The other buttons include MENU (for access to the full electronic menu), ▣ (for setting exposure compensation), AEL (for Autoexposure Lock), DISP (for modifying the type of data presented in the LCD screen), ▶ (Playback, for viewing all images on the memory card), ⊡ Smart Teleconverter (for 1.4x or 2x image magnification in Quick AF Live View), and 🗑 (for deleting images). The functions that can be accessed with the various buttons will be discussed in greater depth in the pertinent sections of this guide.

NOTE: The ▣ button is also marked ▦. While in Playback mode, pressing that button switches the display to showing many images at one time, as small thumbnails. In M mode, the ▣ button has an entirely different function (since exposure compensation cannot be used in that mode). That's why it's also marked AV (for aperture value). While in M mode, keep the ▣ button depressed and rotate the control dial to change the aperture (f/stop). When you want to change the shutter speed in M mode, release the ▣ button and rotate the control dial.

On the front of the camera below the lens release button, there's a switch with two options: AF for autofocus operation and MF for manual focus operation. If using a Sony or Maxxum/Dynax lens that is equipped with its own AF/MF switch, you can use that control instead of the switch on the camera body.

There is another button marked MF Check LV for activating the Manual Focus Check Live View mode, discussed on page 111.

The α500 and α550 are equipped with an eye-level viewfinder with a Spherical Acute Matte focusing screen and a large, bright, lightweight, and specially coated penta-mirror (instead of the heavier, all-glass pentaprism that is used in some cameras). The finder shows 95% of the image area at 0.80x magnification when using a 50mm lens focused at infinity. The eye-relief is 19mm, indicating that you can see the entire image area when holding the camera—without the rubber eyepiece cup—as far as 19mm mm from your eye. (When the eyepiece cup is on the camera, the eye relief is roughly 15mm.) This is beneficial for those who wear eyeglasses when shooting.

The viewfinder eyepiece allows for a -2.5 to +1 diopter adjustment. Adjustments are made using the small diopter adjustment dial on the right side of the rubber eyepiece cup. If you normally wear eyeglasses, try this feature to determine whether it's adequate to allow you to shoot effectively without your corrective lenses. If not, then make the adjustment while wearing your eyeglasses or ask your retailer about the optional Sony Eyepiece Correctors, which offer higher strengths than those built into the camera.

The viewfinder includes a data display panel (at the bottom of the screen) with information about camera settings in use. Nine square AF area points and the spot metering circle are etched on the viewfinder's ground glass screen. When using the camera in autofocus, one or more of the AF area points light up briefly in red to indicate the point of focus.

By default, the camera's SteadyShot stabilizer system is on. When you are using a long shutter speed, a Camera Shake Warning Indicator ((✋)) appears at the right end of the data panel in the viewfinder. If the camera is set for Live View, a "✋ symbol would appear in the LCD panel. That symbol is a warning that blurring from camera shake is likely. Note too that a shake scale ▄▖▖ is always visible. This indicates the extent of camera shake compensation that the system is providing at any time. The more bars that appear, the more aggressively the system is working.

THE LCD MONITOR

The α500 and α550 are equipped with an LCD screen that displays shooting data, images after they are taken, and a live preview of the scene if Live View is active. The high-resolution, 3-inch (7.62 cm) color LCD monitor with a wide viewing angle is adequately large for convenient image viewing before or after taking a photo. A hinged mechanism allows the LCD screen to be pulled outward and then tilted to a desired position within a 180° range. This is particularly useful when you are using the Live View feature to compose images while holding the camera at a high or a low angle. Set the angle of the LCD screen as required and the display will be easy to see.

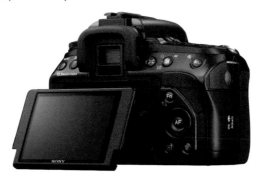

°Sony

Unlike some other camera models available, there's no small data panel on the α500 or α550 because the large LCD screen displays important recording data and camera settings. It also displays the various items and options when you use one of the analog buttons or the Menu or the Function sub-menu for convenient navigation and camera control.

If the camera is set for using the optical viewfinder (OLV) the LCD monitor automatically turns off when you hold the camera to your eye; this is achieved through the use of the eye detector sensor under the viewfinder's eyepiece. This conserves power and eliminates the distraction of seeing the lighted display while shooting. When you move the camera away from your eye, the data display switches back on automatically. You can deactivate this feature by selecting **[Off]** for the **[Auto off w/VF]** item in the Custom Menu ✿ but I do not recommend doing so because battery consumption would be greater.

QUICK AF LIVE VIEW

The LCD monitor can also be used to preview images in Live View mode. In order to use Live View instead of the optical viewfinder for composing images, flip the switch on the camera's right shoulder from OVF to the LIVE VIEW position. When you do so, Quick AF Live View provides a real-time preview of the scene on the LCD monitor. (A small shutter is also automatically activated to block the camera's eye-piece so stray light will not affect the live preview image or the exposure.) Learn more about Live View on page 109.

MANUAL FOCUS CHECK LIVE VIEW

The α500 and α550 are the first Sony cameras to benefit from this second mode that is primarily intended for use when the camera is on a tripod. In this mode, only manual focus is available but the preview image is superior in resolution and it's brighter and less "grainy" in low light. The preview display is also more accurate in depicting the actual results that changes in ISO, White Balance, and Creative Style settings will produce. When you press the MF Check LV button, the camera's reflex mirror flips up and the live preview display is provided by the large, ultra-high resolution CMOS sensor. (In Quick AF Live View, a tiny secondary sensor, with lower resolution, provides the preview image.) The extra brightness makes it more useful for checking composition and focus, especially in low light conditions. Learn more about Manual Focus Check Live View on page 111.

AUTO REVIEW, PLAYBACK, AND DATA DISPLAY

The LCD monitor displays an image for two seconds for quick review immediately after shooting; this feature is called Auto Review by Sony, but photographers often call it instant playback. The LCD can also be used to examine any and all recorded images on your memory card at any time by pressing the Playback ▶ button. In addition to these two features, the LCD is used to review and preview shooting data about images as well, including such choices as shutters speed, aperture, white balance, and more. This data display can also show a histogram for each image's exposure. These three features will be reviewed more closely in the following sections, Playback Options and Data Display.

PLAYBACK OPTIONS

By default, the cameras are set to provide Auto Review (commonly called instant playback) after you take a photo whether you're using the optical viewfinder or either of the two Live View modes. That's fine for a quick confirmation of the exposure and composition of the photo you just took, especially if you set the viewing period to longer than 2 seconds with the Auto review item in Custom Menu ✿.

∧ Use Auto Review to check your images for sharpness and exposure. This way, you'll know if you need to reshoot an image before you move on.

When you're ready to review many of the images, the full Playback mode allows you to do so. Access this mode by pressing the ▶ button. Use either the control dial or the left/right controller keys to scroll through the images.

Magnified View: There's a useful feature in the full Playback that allows for viewing small sections of an image at high magnification. Use it to check sharpness in specific areas of an image, look for red-eye, gauge facial expressions in people pictures, and so on. In order to magnify an image in Playback mode, press the AEL button; it's also marked with a ⊕ icon. Press it several times for higher magnification. You can scroll around the image using any of the four keys on the controller to examine

different portions of the enlarged picture. To decrease magnification, press the ⊡ button which is also marked with an ⊖ symbol. To quickly return to viewing the full image (without magnification) press the ▶ button again.

Index Display: The second handy feature is the ability to view small thumbnails of multiple images. While in Playback mode, press the ⊡ button which is also marked with a ▦ symbol for index display. When you press the button, a new screen will appear showing nine thumbnail photos. This feature is useful to search for a shot stored on your memory card because you can look at more than one picture at a time (although the images are small). You can scroll to a desired photo; press the AF button if you want to view that on the full screen. If your memory card contains numerous images, continue scrolling past the last displayed photo and the screen will show the next nine photos.

Slide Show: You can also review images as a slide show on the LCD monitor with the [Slide Show] item in the ▶ 1 menu; (see page 94 for setup information). Each picture stored on your memory card will display for 3 seconds before the next image automatically appears. You can shorten or extend the display time for each slide show image with the [Interval] item in the same menu and set [Repeat] if you want the camera to keep playing the slide show continuously.

PLAYBACK DATA DISPLAY

While viewing an image that you have taken—either in the full playback mode or in instant playback (Auto review)—pressing the DISP button several times changes the amount of data, and the type of data, that is displayed. You can choose to have no data, only the essential data, or a great deal of data as to settings used to make that photo. The screen with the maximum amount of data also offers four histogram scales (discussed in detail in the Camera and Shooting Operations chapter) for evaluation of exposure and contrast.

DELETING IMAGES

You can delete pictures one at a time in either instant playback (Auto review) or in the full Playback mode. Simply press the 🗑 button. Scroll up to highlight [DELETE] on the confirmation screen, then press the AF button to complete the single image deletion.

In addition to this feature, the α500 and α550 provide the ability to delete images that you "mark" for deletion or all images in a folder. Activate either of those features if desired with the [Delete] item in the ▶ 1 menu (see page 92).

PROTECT IMAGES FROM DELETION

Before deleting any images, you may want to protect important ones from unintentional erasure using the lock feature. You can use the [Protect] item in the ▶ 1 menu to mark images, and thus protect them from deletion. You can always remove the protection from any image at a later time. See page 94 for details.

The [Format] item in the ▶ 1 menu will delete all images on a memory card through an electronic process that reformats the card. All images, including those protected earlier, will be erased by that process.

NOTE: Although there is no in-camera method for recovering deleted images, several companies (such as datarescue.com) market software that's designed for this purpose. These programs do not provide a 100% success rate, but some are quite good at recovering deleted JPEGs and, sometimes, RAW files. Some can also recover images—or at least certain images—that were deleted through formatting of the memory card. Look for reviews of such software on the Internet through a web search using keywords such as, image recovery software programs.

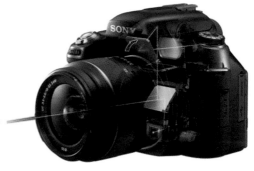

❯ When the camera is set for OVF, it operates like any other D-SLR; the reflex mirror reflects light to the pentaprism and that component reflects light to the viewing screen providing a view of the subject. © Sony

DATA DISPLAY

DATA DISPLAY IN OVF MODE

When the camera is set to OVF (optical viewfinder), the LCD screen displays a graphic interface showing a large shutter speed/aperture scale. If that scale is not visible, press the DISP button until it appears. Other data is also visible: the image size/quality and format, the type of card in use, the remaining capacity (number of shots), remaining battery capacity (in percent), the aperture and shutter speed currently set, the amount of exposure compensation (if any) that has been set, whether flash is on, the drive mode, whether the SteadyShot stabilizer is on or off, the autofocus mode, the ISO level in use, and a DRO indicator.

The graphical interface scale changes as you change to smaller apertures (such as f/16) in P, A, S, or M mode, indicating that the shutter speed will be longer (suitable for static subjects) but that you'll get more depth of field (a greater range of acceptably sharp focus from foreground to background). If you change to a wider aperture, the scale will indicate that the shutter speed will be shorter/faster (more suitable for moving subjects).

When you control the shutter speed, the scale again changes to indicate the change that this will produce in terms of frozen or blurred motion and in terms of more or less depth of field at the smaller or wider aperture that will be used to make a good exposure. Some camera reviewers found this scale to be useful while others did not. After you experiment with it, in Aperture Priority and Shutter Priority mode for example, you'll know whether you find it to be intuitive or not.

Sony provides another feature that is definitely useful. An instant Help screen appears when you press certain control buttons and wait for a second or two. For example, pressing the ☒ button produces the following note: The + direction increases the brightness of the photo and the - direction decreases the brightness. Experiment with the various buttons to see each of the helpful notes that are provided.

Other Display Options: Pressing the DISP button changes the display to a more typical screen, without the graphical display scale. Instead, icons and abbreviations denote the camera functions that are active; some data items in numerals are also visible.

A third press of the DISP button turns off all data displays; this might be useful when you have very little remaining battery capacity. Instant Review will still appear after you take a photo.

When the α500 or α550 is placed in the vertical shooting position, the display automatically rotates for ease of viewing.

DATA DISPLAY IN LIVE VIEW

When the camera's OVF/LIVE VIEW switch is set for Live View mode, data is overlaid on the live preview display but is somewhat different in format than it is when using the optical viewfinder. The graphical display scale appears, but is smaller and fewer items of data are visible.

Pressing the DISP button eliminates the graphical display scale and activates the icons showing the settings in use. They're now at the sides of the screen to provide less interference with the most important parts of the preview image.

If you press the DISP button again, less data will be visible; it will all be in a small panel below the actual preview image display. A histogram scale will now appear over the image, in the lower right corner of the screen. This scale (also available in Playback mode) is not intuitive but it is a useful feature for evaluating exposure and contrast, and will be discussed in great detail Camera and Shooting Operations chapter.

Pressing the DISP button once again will remove the histogram, but the few items of data will remain visible.

NOTE: When the camera is set to Manual Focus Check Live View (with the MF Check LV button) the data display is somewhat different than in conventional Quick AF Live View mode. The most obvious difference is that the graphic interface scale never appears; as well, a histogram is not available.

THE IMAGING SENSOR

While a digital camera's sensor records images in full color, its individual pixels are actually not able to record color values at all. Each pixel captures a portion of the total light falling on the sensor, and they are only able to record the intensity of the light. Therefore, filters are placed in front of the pixels so each can only record one of the three primary colors (red, green, and blue) of light. These filters are arranged in a specific order, most commonly using a pattern called the Bayer array, where there are twice as many green pixels as there are red and blue.

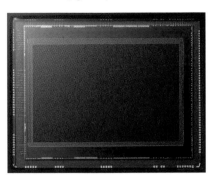

> Sony's Exmor CMOS sensor

When the light projected by the lens comes into contact with the imaging sensor during exposure, the light-sensitive pixels accumulate an electrical charge. More light striking a particular pixel translates into a stronger electrical charge. The electrical charge for each pixel is converted into a specific value based on the strength of the charge so that the camera can actually process the data.

The α500 and α550 employ Sony's Exmor CMOS (Complementary Metal Oxide Sensor) chip with on-chip noise reduction that works with BIONZ processing engine to deliver excellent image quality. Digital noise—resembling graininess or colored speckles—is well controlled, so the cameras allow for shooting at incredibly high sensitivity levels, up to ISO 12800, allowing for an adequately high shutter speed to provide good photos even in interiors lit only by candlelight.

Because each pixel only records the value of one of the primary colors, full color must be processed based on information from adjacent pixels. The final image data is then written to the camera's memory card as an image file. An exception to this would be the RAW capture format,

which records raw data (actual pixel values) from the sensor and stores it in a special file format (ARW) that needs to be processed using special software in order to be a viewable image format..

In addition to the Bayer array pattern, a low pass anti-aliasing filter is located in front of the sensor. This reduces the wavy colors and rippled surface patterns (known as moiré) that can occur when we photograph small, patterned areas with a camera that uses a high-resolution sensor.

THE SENSOR AND EFFECTIVE FOCAL LENGTHS

As with the vast majority of digital cameras, the sensor used by the α500 and the α550 is smaller than a 35mm film frame, which measures 24 x 36 mm. The sensor in these digital camera is approximately 23.4 x 15.6 mm in size. Hence, the scene through a lens is different than it would be if mounted on a 35mm camera. Many seasoned photographers like to think in 35mm SLR terms, so they often describe lenses on D-SLRs by their "effective focal lengths." To calculate this effective focal length, multiply by 1.5. For example, a 28–75mm zoom becomes equivalent to a 42–112.5mm zoom in the 35mm format. The smaller sensor reduces the wide-angle capability of the lens, but increases its capacity for telephoto zoom.

This 1.5x factor for effective focal length, or "focal length magnification," is actually a field-of-view crop. In other words, the focal length is not actually increased. The apparent magnification occurs because the small sensor records a smaller portion of the scene than a larger 35mm film frame would. Consequently, the image appears as if it had been taken with a longer lens, one with a narrower field of view that encompasses less of any scene.

This factor is certainly useful in wildlife and sports photography as it reduces the need to use super telephoto lenses (i.e., 500mm or greater) for tight shots of a distant subject—a moderate telephoto lens (such as the long end of a 75–300mm zoom) will often do the job. But in wide-angle photography, the effective focal length magnification is a drawback because we need extremely short focal lengths to create images with a true ultra-wide effect. That's why Sony is offering shorter, or wider, lenses, such as the 11–18mm zoom; at its short end, this lens provides the ultra-wide field of view that we would expect from a 16.5mm lens on a 35mm camera.

^ The 1.5x focal length magnification provided by the 23.4 x 15.6 mm sensor produces a field of view crop providing apparent magnification of a distant subject.

CAMERA CARE AND CLEANING

Keep your α500 or α550 and all lenses clean and well protected when not shooting. Do not expose the camera or lens to water, dust, sand, or salt. A camera bag and a clean, dry storage environment should prevent dust and dirt buildup. Always keep the body cap on the camera when a lens is not mounted; this will prevent dust and contaminants from getting inside the body and settling on the sensor. Keep the front and rear caps on your lenses as well. When you set the camera down, be sure that the lens is not pointing toward the sun, to prevent damage to the CMOS sensor.

Always switch the camera off before mounting or removing a lens. This will minimize static electricity, reducing the amount of dust that will be attracted to the CMOS sensor. When shooting in a location with a great deal of sand or dust, do your best to change lenses quickly in a protected spot. Hold the camera pointing downward when changing lenses. In spite of the automatic sensor cleaning feature, it's still wise to minimize the amount of dust that enters the camera.

In addition, do not leave the camera in hot locations, such as the interior of an automobile parked in the sun. Try to minimize exposure to

extreme humidity. In such conditions, keep the camera/lens in a camera bag when not in use.

When storing your camera for more than a week, remove the battery and the memory card. In order to minimize the risk of lost data, do not place the card near a magnet (as in audio speakers) or near any appliance that produces high static electricity discharge. And keep your camera bag immaculately clean; use a vacuum cleaner to remove dust and other contaminants from the bag on a regular basis.

Put together a basic camera care kit, including two microfiber cloths and photographic lens cleaning solution, plus a large blower bulb for blowing dust out of the camera interior. All such accessories are available from photo retail stores. Also carry a soft, absorbent cotton cloth (an old 100% cotton T-shirt perhaps) to dry off the exterior of the camera and lens when working in damp conditions. (Do not shoot in rain or snow unless the camera and lens are well protected.)

Dedicate a microfiber cloth for the purpose of cleaning your lenses; do not use it for other purposes, such as cleaning a smudged LCD monitor; use a cloth of a different color for that. In most cases, a gentle breath of warm air on the front element plus a quick wipe with the microfiber cloth is all you do to clean your lens. To remove stubborn smears or fingerprints, use a photographic lens cleaner solution. Do not use solutions designed for other purposes such as cleaning eyeglass lenses. Apply a drop of solution to a small part of the microfiber cloth; do not pour it onto the front or rear element of the lens because liquid may seep into the optics. Wipe away any of the solution using a clean, dry part of the microfiber cloth.

CLEANING THE CMOS SENSOR

Whenever you shut the α500 or α550 camera off, the Anti-Dust system will vibrate the entire CMOS sensor assembly to shake loose particles off the filter that covers this chip. However, sticky particles or dust in dry climates may remain on the sensor. Prevention of dust accumulation is definitely preferable to cleaning. You'll know if the sensor becomes dusty because spots will appear in your images. In that case, you may decide to clean the sensor. The exact method for doing so requires the use of the Cleaning mode item in the camera's Setup menu ⚒ 3; (this process is detailed on page 101).

^ Caring for your camera will keep it clean and in good working order so you can continue
to rely on it for great shots when opportunities arise.

Digital Recording and In-Camera Processing

FILE FORMATS

A digital camera processes analog image information from its sensor and converts it to digital data. Typically, the conversion results in 8- or 12-bit color data for each of three different color channels: red, green, and blue. A bit is the smallest piece of information that a computer uses—an acronym for binary digit (0 or 1, off or on).

One great feature of the α500 and α550 is the ability to record a RAW file in Sony's proprietary ARW format. What sets RAW files apart from other file types is that they have undergone little or no internal processing by the camera. These files also contain 12-bit color information, which is considerably more data than an 8-bit JPEG. However, you must use editing software that is compatible with this particular RAW format. Sony bundles just such a program with the camera: Image Data Converter SR. You can also use Adobe Photoshop CS4, Adobe Photoshop Elements version 6.0 or later, Adobe Lightroom, or another brand of software that is compatible with Sony's ARW format.

The other recording option is JPEG (Joint Photographic Experts Group). While this is a type of file, is also an international standard for the compression of images; it reduces the size of a file, allowing more pictures to fit on a memory card. It is also the most common file type created by digital cameras. When a photo is recorded in JPEG form, proprietary processing takes effect. The camera's processor evaluates the 12-bit image, makes adjustments to it, compresses the image, and

reduces color depth to 8-bit. Because this process discards what it deems "redundant" data, JPEG compression is referred to as "lossy." When the file is opened in image editing software, the program will rebuild the JPEG file based on existing data. However, the finer the JPEG quality option that you select with the camera, the less original data is discarded.

After the JPEG file is downloaded and enhanced in image editing software, it should be saved as a TIFF or in the image-processing software's native format (such as Photoshop's PSD file type). That will prevent further loss of quality that can occur when re-saving a file as JPEG, with additional compression.

Both RAW and JPEG files can give excellent results. The unprocessed data of a RAW file can be helpful when faced with tough exposure situations, but the small size of the JPEG file is faster and easier to deal with. You can also set the camera to shoot a RAW file plus a Large/Fine JPEG and get the best of both worlds—each photo saved in both formats.

RAW CAPTURE

The amount of data in RAW files allows more adjustment latitude in image-processing software for color, white balance, contrast, and exposure. In other words you can make more significant changes to many aspects of the photo without the degradation of quality that can occur when a JPEG is over-processed in a computer. Generally, you can also expect more pleasing prints at larger sizes (e.g. 13 x 19 inches (33 x 48 cm)) from files originally shot in RAW.

NOTE: In RAW capture, the camera's processor records the in-camera settings used for aspects such as color saturation, color mode, contrast, white balance, and sharpness. However, those aspects are not actually locked into the ARW format file by the camera as they are with JPEGs. Hence, you can retain the in-camera settings or change them as desired when using a RAW converter software program.

Let's say you are shooting inside a stadium under sodium-vapor lighting and you forget to change from the auto white balance setting. At the end of the day you notice all your images exhibit a strong colorcast. Or perhaps your exposure was a bit off for some of the shots at one end

of the field. You'll usually have better results correcting these types of problems with ARW format compatible software if you were shooting in RAW capture mode.

While no software can work miracles with a grossly over or underexposed image, you should be able to correct moderate exposure errors (plus or minus one stop or EV) without giving the RAW image an artificial look. Major changes can also be made to other aspects of an image, such as color, contrast, and white balance, without negative effects on the pixels.

Yet working with RAW does have certain drawbacks. The larger RAW files consume more space on a memory card than JPEGs. In addition, adjusting and converting ARW format files—before a final fine-tuning in your conventional imaging software—adds extra post-processing time. That can be a problem after you return from a long trip with hundreds of images.

The most important factor in deciding which image format will work best for you is your own personal shooting and working style. If you want to shoot quickly and spend less time in front of the computer, JPEG might be the best choice. If you loved working in the darkroom and processing film, then RAW is a great continuation of that process. If you are dealing with problematic lighting, shoot in RAW for the superior correction possibilities available with the ARW format files. If you have tons of images to deal with, JPEG may be the most efficient because you will not need to first convert every photo using the special software.

IMAGE SIZE (RESOLUTION)

For digital cameras, resolution indicates the number of individual pixels contained on the imaging sensor. This is usually expressed in megapixels (MP), an abbreviation for millions of pixels. Thus, a 12.3MP camera has 12.3 million pixels covering the sensor while a 14.2MP camera's sensor employs 14.2 million pixels for image recording.

You don't always have to utilize the camera's maximum resolution. The α500 and the α550 offer the choice of three different JPEG resolution settings, or image sizes, in which to record. Generally it is best to use the highest setting available to take the most finely detailed pictures. This also gives you more flexibility to crop or to make large prints. You can always reduce resolution later with image-processing software in the computer.

^ The 3:2 default aspect ratio is perfect for making 4 x 6 inch (10 x 15 cm) prints; however, slight cropping will be required if using other print sizes in order to fit the aspect ratio of the paper.

JPEG IMAGE SIZE

Below are the three options available when selecting JPEG image size. (RAW capture will always utilize the camera's maximum number of pixels.) Scroll to the [Image Size] item in the ◖ 1 menu with the four-way controller's keys, press the central AF button, scroll to the desired image size option, and press the AF button again to confirm your selection. The α500 allows you to choose from Large, Medium, and Small sizes for JPEG capture in the conventional (and default) 3:2 aspect ratio. Note that the file sizes differ in their height and width dimensions, as well as in the amount of memory they take up on a memory card or computer.

- O L: 12M: 4272 x 2848 pixels
- O M: 7.4M: 3104 x 2072 pixels
- O S: 3.0M: 2128 x 1416 pixels

Since the α550 employs a sensor with more pixels, the available JPEG size options are different. Here are the options in the conventional 3:2 aspect ratio format.

- O L: 14M: 4592 x 3056 pixels
- O M: 7.7M: 3344 x 2224 pixels
- O S: 3.5M: 2288 x 1520 pixels

ASPECT RATIO

By default, the α500 and the α550 generate photos in a typical 3:2 aspect ratio format, of the right shape for making a 4 x 6 inch (10 x 15 cm) print. This produces the largest possible images in terms of the number of pixels. However, Sony also provides a 16:9 aspect ratio for making longer/narrower images that conform to the shape of a widescreen TV monitor. This alternative can be selected with the **[Aspect Ratio]** item in 📷 1. That can be useful if you plan to display your photos for friends on a large television monitor or like the panoramic image size. Note, however, that the long/narrow format is not ideal for making prints on standard paper sizes. As well, the image will contain fewer pixels because the camera crops part of the actual photo. Hence, it's better to always use the standard 3:2 option and crop any photos that you want to display on a wide screen TV using image editing software.

When you select the 16:9 aspect ratio, the α500 will provide the following options under **[Image Size]**. Note that the maximum size (resolution) is only about 10MPs, because the camera crops the image into the long/narrow size, discarding some pixels.

o L: 10M: 4272 x 2400 pixels
o M: 5.4M: 3104 x 1744 pixels
o S: 2.5M: 2188 x 1192 pixels

If you set the Aspect Ratio to the 16:9 format with the α550, the image sizes will be slightly larger than the α500, with the largest option providing an image with roughly 12MP resolution.

o L: 10M: 4592 x 2576 pixels
o M: 6.3M: 3344 x 1872 pixels
o S: 2.9M: 2288 x 1280 pixels

There may be situations where it is preferable to shoot at less than maximum resolution. Lower resolution (smaller) image files save storage space and processing time when compared to larger files. You can fit more of them on your memory card and you can take more shots in a single series. The smallest JPEG size may make sense in a situation where you want photos strictly for Internet use, and perhaps for making only small prints. Do note, however, that even a Small

2.5MP or 3.5MP file is probably larger than you would want to use on a Web site or as an attachment to an email; it would need to be downsized further in image-editing software. Therefore, it is again recommended that you always shoot with the largest file size, and downsize later if needed.

IMAGE QUALITY (COMPRESSION)

Image quality refers to the amount of compression you want the in-camera processing engine to apply. Compression reduces the size of the files recorded to the memory card; the greater the compression, the lower the quality of the file. Four options are available under the **[Quality]** item in the 📷 1 menu. This is the full list:

- **RAW:** (ARW format) Some "lossless" compression is automatically applied; the image maintains full quality.
- **RAW & JPEG:** Full quality for the RAW capture and the least amount of JPEG compression (JPEG Fine) for optimal quality.
- **Fine:** Only a JPEG will be recorded with the least amount of compression in order to maintain optimal quality.
- **Standard:** A higher amount of compression will be applied to the JPEGs, producing smaller, lower quality files that consume less space on a memory card.

⌃ The RAW capture format produces slightly higher-quality images than JPEG, but a memory card holds far fewer ARW files than JPEG files.

The Standard JPEG quality option might be useful at times—when you don't have much capacity left on your memory card, for example. However, be aware that increased compression creates an image that is less fine. At this higher compression rate, more data is discarded to make the JPEG file smaller. When the photo is later opened in a computer, the imaging software restores the missing pixels by copying adjacent pixels. This procedure is not perfect however, so JPEG artifacts, such as jagged subject edges, may appear. Unless you have a specific reason for selecting the Standard JPEG quality, stick to using the Fine option.

MEMORY CARD CAPACITY

The chart below shows the number of images that you can save to a 4 gigabyte (GB) Memory Stick PRO Duo when using the highest (Large) image size or resolution—and the conventional 3:2 aspect ratio—with the α550. For some reason, an SD or SDHC card will hold slightly fewer images, but the difference is negligible.

- ○ JPEG Standard: 893 shots
- ○ JPEG Fine: 633 shots
- ○ RAW & JPEG: 184 shots
- ○ RAW: 260 shots

Because the α500 generates images with lower (12.3 versus 14.2 megapixel) resolution, a 4GB card will hold more photos, as follows.

- ○ JPEG Standard: 1015 shots
- ○ JPEG Fine: 730 shots
- ○ RAW & JPEG: 210 shots
- ○ RAW: 296 shots

WHITE BALANCE

Unlike the film used in conventional cameras, the sensors in digital cameras can be adjusted for different color temperatures of light. In other words, we can cause the camera to produce a natural-looking image, rendering whites as pure white in various types of lighting. When the whites are accurate, other tones are accurate as well, without a strong color cast. This is known as adjusting the white balance (WB).

WHITE BALANCE—HOW IT WORKS

Every light source emits a different range of wavelengths, varying from primarily short (appearing blue) to primarily long (appearing red). Even the light from the sun can vary. It is cooler (bluer) on overcast days than during a sunrise or sunset (warmer, redder). While our brain perceptually adjusts for these differences, photographic film and digital sensors record them more objectively.

The color of light is defined numerically using the Kelvin color temperature scale. Lower Kelvin temperatures denote the warm, reddish light produced by a bonfire, an incandescent lamp, and the sun when it is low in the sky. Higher Kelvin temperatures denote the cool, bluish light at twilight, on heavily overcast days, or in a shady area.

On the Kelvin scale, full sunlight (mid-day) is typically between 5100K and 5500K. The light on an overcast day is usually between 5500K and 6500K. In full shade, the light is even bluer: typically between 7000K and 8000K. The range provided for these different types of light is quite broad because it is affected by the exact time of day, the extent of the clouds that filter the light from the sun, the time of year, and atmospheric factors such as haze, smog, fog, or dust particles in the air.

Artificial light sources also produce light with certain color temperatures. Household tungsten lamps produce light with an orange cast (about 3200K). Most fluorescent tubes produce greenish light. Unusual lamps, such as sodium vapor and mercury vapor, produce light with a strange color that can be difficult to define.

In order to produce images with clean whites (and hence, accurate tones overall), digital cameras can be adjusted for the specific color temperature produced by these various light sources. This is referred to as white balance (WB). The α500 and α550 provide several options

^ This is an example of a scene with several colors of light; it is "cool" in the shadow areas, "warmer" in sunlit areas, and amber or red in areas illuminated by artificial lights.

for setting the WB for various types of lighting conditions, although the default setting is an option called Auto White Balance (**AWB**). When **AWB** is being used, the camera's processor attempts to automatically detect the type of existing light and compensate accordingly to provide accurate color balance.

This feature is designed to analyze the color of light and set an appropriate color temperature to render whites as white. This system works quite well outdoors, especially on sunny or partly cloudy days, and indoors with flash. It's an especially useful choice when the light is changing rapidly (from sunny to cloudy to sunny again), or when shooting subjects that move from one type of lighting to another—sunlight to shadow, for example. But **AWB** does not always work so well under manufactured lighting such as tungsten or sodium vapor.

Some of the other options for controlling white balance in a broad variety of lighting conditions are straightforward and intuitive. Others are complex, of the type you would expect in a camera designed for professional photographers. While you may not plan to use all of the options, it's worth understanding how they work and why they might be useful.

PRESET WB SELECTIONS

You can usually get more accurate white balance rendition in mixed or artificial lighting than **AWB** by selecting a specific WB setting—called a preset—designed specifically for those conditions. To select from the white balance options, press the 🔲 button to access the Function sub-menu. Scroll to the **AWB** item and press the AF button in the center of the four-way controller. A list of WB options now appears. Scroll down to review the entire list, using the controller's keys or the camera's control dial. When you reach the one that is closest to the actual lighting conditions being shot in, press the AF button to enter and confirm your selection. Note too that scrolling to the right from any of the items provides an extra option.

The available options are denoted with symbols. Scroll to one of the presets, wait for a second, and a screen will appear providing a brief summary of the purpose of that preset. Shade WB 🔳 for instance, shows the following explanation: *For shooting in shaded areas in sunny weather.* Let's take a look at each of the presets and the processing that will be applied by the camera when that option is selected.

☀ Daylight: The processor assumes that the light is white, or close to it, and does not add any color.

🔳 Shade: Because the light in a shady area is very blue, the processor adds amber to try to correct this effect, to render whites as white instead of blue. That often provides a pleasing effect, although some tweaking may be required later, with imaging software.

☁ Cloudy: On a cloudy day, the light is slightly blue, so the processor adds a bit of amber. Usually, this provides a pleasing effect.

💡 Incandescent: The light produced by old-style light bulbs (also called tungsten bulbs) is a deep yellow, so the processor adds blue. This rarely provides an image with accurate white balance; some extra fine-tuning with imaging software will usually be required. These days, many light bulbs are daylight balanced and produce light that is closer to white; depending on the specific bulb you are using, the **AWB** option may produce a more accurate white balance.

※ Fluorescent: This preset is designed for shooting a scene illuminated by cool white fluorescent tubes; those produce a slightly green light so the processor adds a bit of magenta to compensate. Problem is, every fluorescent tube produces a slightly different color of light, so this WB preset varies in terms of its effectiveness. Also, the new fluorescent light bulbs can produce illumination that is closer to white, making **AWB** a better option. If you often shoot without flash in the same location, under fluorescent lighting, experiment with the preset and with **AWB** to determine which provides the most pleasing effect.

※ Flash: Because the light produced by a flash unit tends to be a bit cool (blue), extra processing adds a hint of yellow and magenta. You may find ※ to be perfect, but you may prefer the effect provided by **AWB** in flash photography in dark locations.

NOTE: When using flash merely to lighten shadows in a scene where sunlight (or another light source) is the primary source of illumination, do not select the Flash ※ preset. Instead, use **AWB** or make your WB selection based on the type of illumination that is the main light source for the shot. Reserve the ※ preset for low light photography when the subject will be primarily lit by the electronic flash.

WB Preview: You can experiment with the effect that each of the presets will provide on the scene that you plan to photograph. Press the MF Check LV button to set the camera to Live View with the best, most accurate display. Only manual focus will be available in this Live View mode, but for previewing WB effects, that is not relevant. (When you're ready to start taking photos, you can switch to the conventional Live View mode or to OVF if you prefer to use the optical viewfinder). Access the WB feature in the Function sub-menu and scroll down among the presets. As you do so, the overall color balance of the live preview image will change to reflect the modification that the camera's processor would produce In terms of the overall color balance with each of the presets.

HINT: If you want to pre-visualize the effect that each WB preset will produce on the scene while using Live View, start scrolling through the WB presets quickly, before the camera produces the explanatory text screen that will block most of the preview display. Or, set the Help Guide display item in the ⚒ 3 menu to Off by scrolling to the right from that item, scrolling to Off, and pressing the AF button. Now, the camera will never block the preview display. Later you might want to set the Help Guide back to On, since it can be useful when experimenting with other camera features.

CREATIVE USE OF WB PRESETS

Using the "wrong" WB setting can yield some interesting creative effects. For example, the 🦆 preset can be used when the sun is shining brightly to create an effect resembling that produced by a pale warming filter. For a stronger warming effect, try the 🏠 preset; that will produce a very obvious yellow/orange color cast.

The ☀ preset produces the opposite—a strong blue cast, useful with some winter scenes for a much "cooler" effect. Experiment with using the various preset choices for creative purposes. You can always check the results in the camera's LCD monitor.

WB LEVELS ADJUSTMENT

In addition to selecting the presets, you can modify the processing that the camera will produce for each of the WB options. This override can minimize the amount of fine-tuning that will be required later with imaging software. Scroll to the right from any WB preset to reveal the WB Adjustment item; you can then scroll left/right to modify the amount of levels adjustment. Select a plus [+] factor for a warmer (more red/yellow) effect. Or set a minus [-] factor for a cooler (more bluish) effect. You can make adjustments within a range from +3 to -3.

You may find the WB levels adjustment option useful. In order to evaluate the effect that any adjustment will produce, use the preview method discussed in the previous section. You should also take some photos with each of the WB adjustment levels in a specific WB preset such as 🦆 on a cloudy day; later, examine those images on a large computer monitor to fully appreciate the effect that each adjustment level produced.

After using the preview and the experimentation, you may decide to permanently leave the α500 or α550 set to a -1 factor for 🌩 WB if you find that the camera routinely makes images that are slightly too yellow in such lighting. Or you may decide to permanently set a +1 factor for ⚡WB if you find the camera routinely produces images that are slightly too blue when using flash.

Once you have set a WB level adjustment, the camera will retain that setting until you readjust it, even after turning the camera off. It will be used whenever you select that specific WB preset in the future.

HINT: WB levels adjustment is not very scientific because the exact color of light often varies within a broad range, as on a cloudy day, for example. When shooting in lighting conditions where the camera routinely makes images with inaccurate white balance, I strongly recommend using the Custom WB 📷 feature (discussed below) instead.

ADVANCED WB OPTIONS

In addition to the presets and levels adjustment, the cameras offer three additional features that you can use to modify the white balance. These options are covered in the order of their usefulness.

📷 CUSTOM WB

Scroll down to 📷, the final item in the White Balance list if you want to use a feature to set the WB value for any type of lighting. In simplified terms, this feature teaches—or calibrates—the camera to render whites as white regardless of the color of the light. When whites are accurate, other colors will appear natural as well. Though a sophisticated function, it is not overly complicated to set. It is well worth the bit of extra effort to learn because this feature virtually guarantees good white balance under any unusual or tricky lighting condition. It will be particularly useful when taking photos, without flash, under various types of artificial illumination that generates unusual colors of light.

For ◣⧄ WB, a sheet of white paper or a gray card is needed as a target in order to calibrate the camera. This works best when flash is not used (when flash will be the primary source of light, the **AWB** or ⚆ preset works very well). In order to set ◣⧄ WB for a specific lighting condition, follow these steps exactly as specified. It is a good idea to photocopy them for handy reference while you're out shooting.

1. Scroll to the ◣⧄ item in the list of WB items Function sub-menu, and scroll to the right to the Custom Setup item. Press the AF button to confirm your decision to proceed with the ◣⧄ WB calibration.

2. Place the white sheet of paper or gray card in the same light that will illuminate the most important part of the subject when you take your planned photo. (For a portrait for example, ask the person to hold the sheet or card at his or her face.)

3. Look through the viewfinder and point the lens so the central area of the frame (within the circle etched on the viewing screen) is filled with your white or gray target. Be careful not to cast a shadow over your target. The white or gray sheet does not need to be in focus. If the autofocus system keeps trying to focus without success, switch to manual focus with the AF/MF control on the front of the camera or on the lens.

4. Press the shutter release button all the way down. The camera will take a photo of your white or gray target. When it does so, it also calibrates the WB system. In other words, it registers the settings required to render a white sheet as white, or a grey sheet as grey, for accurate white balance under the specific lighting conditions. An image of your target will now appear in the LCD monitor with the words "Custom white balance" above it. (This temporary image is not actually saved to the memory card.)

If the displayed image looks neutral—without a color cast caused by the lights illuminating the subject—the calibration process has been successful. If not, touch the shutter release button to return to standard operation, access the ◣⧄ WB item in the Function sub-menu, scroll to the right to set Custom Setup, and start again.

⌃ Some scenes illuminated by artificial light can provide a pleasing image in spite of a strong color cast, but if you want precise results, calibrate the WB system with the ◣ item.

HINT: The primary reason for problems in trying to set ◣ WB is the failure to scroll to the right to the Custom Setup option. You must remember to do so the first time you try to calibrate the ◣ WB system, and for any subsequent calibration. If you had not scrolled to Custom Setup, the camera will simply take a photo; it will not calibrate the ◣ WB feature.

When calibration is finished, the camera is set for ◣ WB. You can now remove the white sheet or grey card from the scene. Switch back to autofocus if you had previously set manual focus. Recompose to take the desired photos. As long as the type and color of the lighting does not change, you can keep taking photos and get accurate white balance.

On rare occasions, you'll get a "Custom WB error" message in the LCD monitor, indicating that the system cannot calibrate under the existing conditions. This is most likely to occur when a white target is illuminated by extremely bright light or if you used flash for the calibration process. In that case, try again after pushing the flash back into the down position. If you again get an error message in extremely bright light, you will need to calibrate using a gray card (instead of a white sheet) because it reflects less light; the calibration process should then be successful.

The α500 or α550 saves the last ◣ WB setting that you have created. Whenever you set the camera to ◣ WB it will always use the calibration settings that you created. That will not change even if the camera is turned off. Whenever you activate ◣ WB, even months later, it will automatically recall the WB setting you had previously set. This can be useful if you often return to shoot in the same sports arena, for example, where the lighting is always the same. If you decide to take photos in entirely different lighting with ◣ WB, you will need to recalibrate the system.

WB BRACKETING

This is a feature that causes the camera to generate three images of the photo that you take, varying the WB for each image. It's available with all of the WB options when shooting JPEGs. (It is not necessary with RAW since you can easily change the color temperature when processing your ARW format files.)

Access this feature by pressing the Drive mode button ♻/ ▯ on the top of the camera or in the Function sub-menu. A screen with various options will appear on the LCD monitor. Using the controller keys or the control dial, scroll to the ᴮᴿᴷ item. The words WB Bracket will also be displayed on the LCD screen.

The ᴮᴿᴷ symbol (the default setting) indicates a low level of WB bracketing over three images. The camera will produce three JPEGs every time you take a single photo, with only a slight variance in WB. A second option, Hi—for a higher degree of WB variance—is also available. You can select that by scrolling to the right with the controller key. After making your selection, press the central AF button to enter and confirm your choice.

When you take a single shot, the camera's processing system automatically generates the original image file plus two copies, each with a slightly different WB adjustment. (Only the last of the three images will be displayed on the LCD monitor, but you can view all three in the camera's Playback mode.) One duplicate image will be slightly warmer (red/yellow) while the other will be slightly cooler (blue). The difference will be most obvious if you were using the [Hi] WB bracketing option.

In my experience, this feature is most appropriate when using one of the preset WB options. (Set the desired preset first, before setting the WB bracketing.) It increases the odds of getting an image with the most pleasing color. This feature has some disadvantages: it's available only with Single frame advance; the extra two files consume more space on a memory card; and though it takes less than a second, the extra processing time may cause you to miss a fleeting gesture in candid picture taking.

COLOR TEMPERATURE AND FILTRATION

Available in the Function sub-menu, this WB option allows you to set a specific Kelvin color temperature for white balance purposes. It is intended for photographers who use a color temperature meter or shoot under lighting with a known color temperature, or who follow the manufacturer's recommendations for certain types of lighting. If you aren't using these methods, the camera's other WB options will be more useful.

To try this feature, scroll down to the 5500K - Color Temperature item. (The 5500K is the default setting for color temperature.) Scroll to the right or to the left to set a higher or lower K number. If you also want to apply filtration, scroll down one step from the [K number] to the [Color Filter] item. This is a magenta/green compensation feature that can be used to adjust the WB toward either magenta or green as if you were using filters over the lens, as in traditional film photography. (This feature is most helpful for fine tuning WB for fluorescent bulbs, which tend to produce a green color cast.)

Scroll left to set a [G] option if you want to add a green tint to your image; select the desired intensity from G1 (mild) to G5 (strong). Or scroll right to set an [M] option, for a magenta tint to the desired intensity from M1 to M5. You can use the preview feature in Manual Focus Check Live View, as discussed earlier (on page 111) to visualize the exact effect that any Color Temperature and Filtration will produce.

CREATIVE STYLES

The α500 and the α550 provide a wide range of Creative Styles; each provides a different effect. Select the one that is most appropriate for a certain type of scene. Press the **Fn** button to access the Function sub menu and scroll down to the last item on the right side of the screen. By default this will be set to Standard⁺. Press the AF button to reveal the full list of Creative Styles; scroll up/down among them to see all of the items. Stop at any of the Creative Styles; wait a second and an explanatory Help Guide screen will appear.

Creative Style Preview: To visualize the effect that any of the Styles will produce on the scene you want to photograph, you can switch to the conventional Live View mode. Scrolling through the list of Styles will change the look of the preview image display. For the most accurate display, with the highest possible display resolution, press the MF Check LV button to switch into the Manual Focus Check Live View mode. (Only manual focus will be available but that's fine since you are only experimenting. When you are ready to take a photo, you can switch to the conventional Quick AF Live View or OVF if you prefer to use the optical viewfinder.)

HINT: Start scrolling through the Creative Styles items quickly, before the camera produces the explanatory Help Guide screen that will block most of the preview display. There is another, better option for previewing Creative Styles. Set the **[Help Guide]** display item in the ⚲ 3 menu to Off by scrolling to the right from that item, scrolling to **[Off]**, and pressing the AF button. Now, the camera will never block the preview display with the help screen. Later you might want to set the Help Guide back to On, since it can be useful when experimenting with other camera features.

The Creative Style menu item cannot be selected when the camera is set to one of the fully automatic modes. For experimenting with the various Creative Styles options, set the camera to the M, S, A, or P exposure mode. Let's take a closer look at the effects that the camera will provide when you select any of the Creative Style modes. They are primarily intended for JPEG capture because when you shoot in RAW capture, you can modify any aspect of an image later, using special converter software.

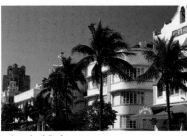

^ Standard Style

^ Vivid Style

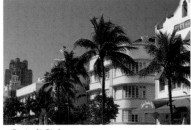

^ Portrait Style

^ Landscape Style

^ Sunset Style

^ B/W Style

Standard: : This is an all-purpose Style mode that produces JPEGs with rich, faithful colors, and moderately high sharpness and contrast.

Vivid: : This Style generates images with deep and vivid colors as well as high overall contrast. (In high-noon lighting the contrast may be excessive, with deep black shadows and very harsh looking highlight areas.) You might want to use it for travel photography for instance, where a particularly bold color rendition is desirable, especially in the soft light of a cloudy day. It is less suitable for portraits because skin tones will not appear natural and the overall effect will be harsh and unflattering.

Portrait : This mode is optimized for the reproduction of skin tones. In-camera contrast, and color saturation are slightly reduced for a softer, more flattering effect with natural (not overly rich) colors.

Landscape : This mode reproduces outdoor scenes with higher than average contrast and boosted saturation in greens and blues. It's similar to Vivid but does not increase the richness of all colors in a scene.

Sunset : Optimized for landscapes at dusk and dawn, this produces a red/yellow color cast when used in daytime shooting. Contrast and color saturation are automatically increased slightly to produce a sunrise or sunset photo with a warm rich glow as well as high color richness.

B/W : Denoting Black & White, this Style will cause the camera to generate images in monochrome and not in color. The tones are neutral and the overall effect is suitable for making prints without adjustments in image-processing software. However, serious black-and-white photographers may not find the default for this Style to be ideal for producing the exact desired effect.

OPTIMIZING IMAGES IN-CAMERA

While scrolling through the Creative Styles, you probably noticed other options on the right side of the LCD screen, along the bottom of the display. These consist of three icons for Contrast ◑, Saturation ⊕, and Sharpness ▨, respectively. Scrolling to the right from any Creative Style option allows you to modify the level of each of these image "parameters" from very high to very low. (There's no need for this feature if shooting in RAW format because the images can be adjusted in the converter software.)

In-camera image optimization is particularly useful if you shoot JPEGs and print directly from the camera or a memory card. If you fall into this category, or if you do not want to spend time optimizing contrast, color saturation, and sharpness in a computer, you may wish to do so in-camera. Simply scroll to the [Contrast], [Saturation], or [Sharpness] item. Then, you can scroll up to boost the level of each of the three parameters to a [+] setting for a stronger effect or scroll down for a more moderate level to a [–] setting for a milder effect.

Let's take a look at each of the three and why you may wish to adjust its level of intensity. Do note that for all three, the default level is zero: a mild intensity. The user selectable levels range from -3 to +3.

◑ Contrast: To reduce contrast in harsh lighting conditions or to create flattering portraits that benefit from a soft look, you may want to set Contrast to -1 or to -2. That is also useful for minimizing the loss of detail in highlight and shadow areas in harsh lighting.

In flat light, such as an overcast day, you might want to try a +1 level for more separation of light to dark elements. Think twice about selecting a higher contrast level for any other type of lighting. Low contrast is easy to fix in image-processing software, but excessive contrast can be difficult to moderate without creating an artificial-looking effect. In fact, you may want to permanently set a –1 level if you plan to enhance your photos in image-processing software.

⊕ Saturation: The α500 and the α550 often produce images with just the right color richness or vibrancy for many types of subjects when you use the [Standard] Creative Style mode. Of course, you may decide that you prefer a less intense color effect for a landscape for a more muted overall look or to avoid the loss of detail in excessively rich colors. (When using a polarizing filter over the lens, color saturation can be especially vivid—not always the desired effect.) That's easy to achieve by setting Color Saturation to a -1 or even a -2 level.

On the other hand, you might want more vivid colors for portraits of a group of circus clowns, for example. In that case, when using the [Portrait] Creative Style, you might set a +1 level for Color Saturation.

▨ Sharpness: Like most D-SLR cameras, the α500 and the α550 produce slightly soft images. If you find that you prefer stronger sharpening—for all photos or in a specific situation—simply increase that parameter to +1. This is particularly useful for those who often make prints without first modifying the images in a computer program.

Again, it's easier to increase sharpness in image editing software than to moderate this aspect. Many programs provide several advanced sharpening tools that produce an even more

natural sharpening effect. They usually provide full control, in small increments, as to the extent of sharpening, to produce the perfect effect for any particular subject and for a specific print size that you will make or order. If you plan to take advantage of these tools, do not set a higher in-camera sharpening level; in fact, some Photoshop experts prefer to set a -3 level in-camera and provide all sharpening during "post-processing" in a computer.

In my experience, a -1 setting for Sharpness works fine for JPEGs that I plan to modify using Photoshop CS4 or Elements 6 or 7. Before making a print, I'll apply Unsharp Mask or Smart Sharpen, selecting exactly the amount that is appropriate for the subject and the print size.

> Setting the in-camera Sharpness to -1 can be useful for minimizing digital noise, especially when shooting at a high ISO. Before making a print, use an advanced sharpening utility in imaging software.

COLOR SPACE

Digital cameras render color based on combinations of red, blue, and green and in terms of hue, saturation, and brightness. The various systems that define these colors are called color spaces. Color spaces were invented with different biases based largely on how images will be created or viewed. Two color spaces are common in digital imaging: sRGB and Adobe RGB. By default, the α500 and the α550 always employ the sRGB color space. That makes sense because sRGB is ideal for on-screen viewing and Internet use. It's also the color space that's preferred for printing by most of the mass market photofinishing labs.

Adobe RGB is the only camera option that will produce images in the Adobe RGB color space with a wider color gamut (recording range) than sRGB. This is useful for making inkjet prints. However, when viewed on a computer monitor, Adobe RGB exhibits less rich colors than sRGB.

Some entry-level image editing software programs do not provide support for the Adobe RGB color space; the Sony and Adobe programs do so, as well as many others. Programs that are incompatible with Adobe RGB will convert the images to the standard sRGB color space, produce an "incompatible color space" error message, or generate an inaccurate display of the colors. If you are not certain that your favorite imaging software supports the Adobe RGB color space, then do not select this Creative Style.

Note too that most commercial printing firms are optimized for printing sRGB images because this is the most popular color space. Hence, you won't want to use Adobe RGB for images that you take or send to a high-volume printing lab (photofinishers, on-line printing services, etc.). Some labs will be able to handle such images but may convert them to the sRGB color space before making the actual prints. On the other hand, labs offering professional-quality custom printing often use the Adobe RGB color space, taking advantage of its wider color gamut. If you use any print-making services, ask them which color space they prefer.

D-RANGE OPTIMIZER (DRO)

This feature is provided by the camera's BIONZ processor and creates images with a wider "dynamic range," or a greater range of visible tones. (It's available in the Function sub-menu where it's called DRO, or by pressing the D-Range button.) A photo with very wide dynamic range exhibits a great deal of detail in both highlight areas and shadow areas. By default, the camera is set for DRO Auto ▦. User-selectable options are also available: DRO Off (to deactivate this feature) and levels adjustment for a weak to intense Dynamic Range Optimizer effect.

According to Sony, "DRO modifies the range from highlights to shadows, including gain and contrast, through its in-camera hardware processing to produce more natural, evenly exposed pictures. The camera's image analysis technology studies the captured image data and instantly determines the best exposure and color tonality for the image before JPEG compression."

^ In high contrast lighting situations, you will often lose detail in the shadows.

Automatic HDR: Scroll down to the final item under the D-Range/ DRO sub-menu and you'll find a unique feature, HDR Auto . The term HDR refers to a "high dynamic range" technique that is available with some imaging software programs that can combine several bracketed exposure photos of a scene to provide an image with an unusually wide tonal range. An HDR image exhibits an unusually great level of detail in both highlight areas and shadow areas, greater even than DRO can provide.

The α500 and the α550 can simplify the software process by putting it in the camera, producing an HDR image automatically. The camera does so by taking two JPEG photos of the same scene, at different exposure levels. The BIONZ processor then merges the two photos into a single image with maximum detail in highlight and shadow areas. The user can set a desired intensity level for an effect ranging from moderate to very obvious.

While Dynamic Range Optimizer and HDR Auto are not exposure control tools per se, it makes sense to discuss both features—and their pros and cons—in the section on Exposure. You'll find the full coverage of these features in the Camera and Shooting Operations chapter.

^ To improve shadow detail, use one of the DRO options. Level 2 was used for this image.

NOISE REDUCTION

Digital images made with any camera can exhibit noticeable digital noise when made at very high ISO levels or during very long exposures. The effect is similar to the grain we see in prints made with high-speed films, but the speckles are more colorful. The "noise pattern" is most visible in mid-tone areas or in dark areas that are lightened with image-processing software.

The camera's Exmor CMOS sensor and BIONZ processor combine to produce "clean" images in most circumstances. By default, the cameras apply extra noise reduction (NR) processing to images made at a shutter speed of 1 second or longer and in images made at ISO levels from 1600 and up. That additional processing minimizes the "grainy" effect; both the sharpness and the color of the specks are moderated. Both NR features are active by default but only in single frame advance; they are automatically turned off when the camera is set for Continuous drive mode ⊒ and cannot be activated with the Menu items.

When the camera is set for Single Shot drive mode ☐, and the P, A, S, or M operating modes, Long Exposure NR can be turned Off if desired and High ISO NR can be set to High, instead of Normal, in the ⚒ 2 menu.

If you often make long exposures, as in night photography, or often shoot at ISO 1600 to 12800, you may appreciate the smoother effect provided by the Noise Reduction features. However, like any camera's NR features, they do produce some drawbacks:

1. The entire image becomes smoother, but slightly softer than it would be without the extra noise reduction processing. Actual resolution can also suffer. At the High level for High ISO NR, both aspects are particularly obvious. That can be corrected to a degree with advanced sharpening utilities in imaging software programs, but that does require some expertise for the best results.

2. There is a delay after you take a shot while the Long Exposure NR feature is on: 1 second for a 1-second exposure, 10 seconds for a 10-second exposure, and so on. During this time the camera is not operable, which can be quite frustrating in situations where you must shoot quickly, like during a fireworks display, for instance. You can turn this feature off, but in exposures of 5 seconds or longer, digital noise will be problematic.

^ As with any digital camera, photos made at extremely high ISO levels—such as 12,800—exhibit very obvious digital noise.

HINT: Many imaging software programs, including RAW converters, have some Digital Noise Reduction utility. In my experience, the results are best when shooting in RAW format and applying the NR feature in the RAW converter software, at exactly the right level for each specific image. You can also buy more advanced software specifically for noise reduction such as Nik Dfine and Picturecode's Noise Ninja. Both are even more effective and versatile, providing a vast range of user-controllable options. On the other hand, they are complicated and time-consuming to use, intended for serious photo enthusiasts and professionals who are very computer savvy.

Before any serious photography with very long shutter speeds or at very high ISO levels, I strongly recommend some experimentation. Find a low light scene that you might want to photograph in the future and shoot it using a 1 second or longer exposure, with the Long Exposure NR feature on and then off. Do the same at a faster shutter speed while using ISO 1600 and then ISO 3200 and each higher ISO level, right up to 12800. Try it with High ISO NR on and then off.

Examine the test images at 100% magnification on your computer monitor. You should be able to quickly decide whether you prefer the smoother effect provided by each of the NR features or the sharper effect—with better resolution but a grainy look—when the NR feature is off. In my own experience, the default settings produce the best results, an acceptably smooth image, without a significant loss of fine detail.

The Menus

Many of the features discussed in the previous chapter are accessible with analog controls or by pressing the **Fn** button, reducing the amount of time needed for hunting and pecking through a multi-page menu. As a result, the α500 and the α550 have fewer menu options than some other D-SLRs, but they still offer an extensive list.

THE FUNCTION SUB-MENU

Before covering each of the Menu items, I'll quickly recap the items available in the Function sub-menu. They are all covered in detail in appropriate sections of this Guide book, but here's an overview for reference purposes.

< Become familiar with the items in the **Fn** sub-menu and the full menu to get the most from your α500/α550.

> While some of the items in this sub-menu can be set with analog controls, this screen is a quick/convenient method of camera control.

To access the following items, press the camera's **Fn** button. Scroll to a desired item and press the AF button to reveal additional options. Remember, not all of the items and options will be available when the camera is set to one of the fully automatic modes, such as **AUTO** or one of the Scene modes.

Drive mode: This item offers the same options as you would get if you pressed the Drive mode button: Single-shot advance ☐, Continuous Advance at Hi ⊒ HI or Lo speed, and two Self-timer options. You can also access the Exposure Bracketing and White Balance Bracketing items here. There's another option for owners of the α550 only: Speed Priority ⊒ for 7 fps continuous shooting, with exposure and focus locked at the first frame.

> If you want to blast off 5 frames per second (fps), select the Continuous Hi Drive mode setting.

⚡ Flash Mode: The options here include Off, Auto, Fill Flash, Slow Sync, Rear Sync, and Wireless flash control.

AF-A Autofocus mode: Select from **AF-S** (Single Shot autofocus), **AF-A** (auto switching from Single Shot to Continuous AF if subject motion is detected), and **AF-C** (Continuous AF for tracking a moving subject as the camera-to-subject distance is changing).

⌐ ¬ AF Area: Three options are available when the camera (or lens
⌐ ¬ with an AF/MF switch) is set for Autofocus: Wide (camera
automatically selects from its nine focus detection points), Spot
(using only the central focus detection point), Local (allowing you
to manually select any of the nine focus detection points, with the
keys of the four-way controller).

[●]₀ₙ Face detection: Available only when the camera is set for Quick AF
Live View, the options are On, to use face detection autofocus and
Off to prevent the autofocus system from looking for faces in the
scene when focusing.

☻ₒₙ Smile shutter: Available only when the camera is set for Quick AF
Live View and Face Detection, the camera will automatically take
a photo of a person when it detects a smile, when this item is set
to On ☻ₒₙ; the degree of smile that will trigger the camera can be
set. By default this item is Off ☻ₒₓₓ.

ISO ISO sensitivity: The options are Auto (for automatic selection
from ISO 200 to ISO 1600 as scene brightness dictates) as well
as ISO 200, 400, 800, 1600, 3200, 6400, and 12800, selectable by
the user. The same options are also available by pressing the ISO
button, for users who prefer approach.

⊡ Metering mode: You can choose from multi-segment (40)
intelligent metering ⊡, old-style Center Weighted ⊡, and Spot
metering ⊡.

⚡± Flash compensation: Access this item if you want to set plus or
minus flash exposure compensation for greater or gentler flash
output. The selection range is +/–2EV.

AWB White balance: Numerous options are available here including
Automatic **AWB**, presets for common lighting situations with
overrides to bias the WB toward Blue or Amber, plus Color
Temperature and Color Filter options, and Custom ◣ for
setting white balance under unusual lighting conditions.

DRO
AUTO DRO/Auto HDR: This item provides options for Dynamic Range
Optimizer, including Off, DRO Auto and DRO with levels control
to optimize detail in shadow areas and in highlight areas. You can
also scroll down to [HDR Auto] to activate the new [High Dynamic

Range] feature; scroll to the right and you can set the level for this item. All of the DRO and HDR items/options can also be accessed by pressing the D-RANGE button.

Vivid⁺ Creative Styles: You can set a Standard⁺, Vivid⁺, Portrait⁺, Landscape⁺, Sunset⁺, or B/W⁺ (black & white) style. Each produces an entirely different effect. After setting a Creative Style, you can also set a higher or lower level for contrast, sharpness, and saturation; the latter is not available when the B/W⁺ style is set.

THE ELECTRONIC MENUS

To access the full electronic menu, press the MENU button on the camera back. A series of tabs identifies each of the pages; scroll to the one you want with the left/right keys of the four-way controller. Then, scroll up or down on any page with the controller keys or with the camera's control dial. A few of the menu items will be blacked out (not available) when the camera is set to one of the fully automatic modes, such as AUTO or a Scene mode.

> After you become adept at selecting items and options in the Menu, the entire process will become second nature.

Most aspects of menu navigation are straightforward. When you reach an item of interest, press the AF button in the center of the controller. That will reveal the options available for that Menu item, such as **[On]** and **[Off]**, or one or more other types of choices. Scroll to the one you want to set and press the AF button to confirm your selection. (You may also need to press the AF button once again at the next screen, if that provides some other option such as OK or Cancel).

If the camera does not automatically return to the full menu screen at that point, press the **MENU** button. If that still does not return you to a full menu screen—while using some of the Setup items—touch the camera's shutter release button to revert to conventional operation; then, press the **MENU** button again and scroll to the desired tab.

NOTE: You will be utilizing the button in the middle of the four-way controller quite often to confirm selections when working with the menu system. As in other chapters, I will refer to it as the AF button because it's marked accordingly and does have one function re: autofocus. In other respects, think of the AF button as an OK button.

THE RECORDING MENUS

These menus let you define image parameters such as size, quality, and format. They are also used to control flash, noise reduction, the operation of the AEL button. Often the default settings are the most appropriate.

RECORDING MENU 📷 1

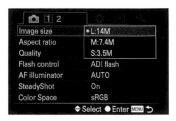

‹ After making your intial settings in this screen, it's unlikely that you will ever need to do so again.

[Image size]: The available options are [Large] (the default), [Medium], and [Small] for JPEG capture with both cameras. The actual size of the images varies because the α550 is a 14.2MP camera while the α500 employs a 12.3MP sensor. (See page 56 for specifics as to the number of pixels in L, M, and S size for both cameras.) By default this item is set to L, for large, so either camera will record an image of the maximum size/resolution. You can change that for JPEGs only. Unless you have

a specific reason for wanting to record smaller images, use the default setting; you can always downsize JPEGs in a computer before uploading them to the Web, for example.

[Aspect Ratio]: Select the standard [3:2] aspect ratio (the default), or choose the longer/narrower [16:9] format. The latter is intended primarily for producing an image proportion or shape that's ideal for viewing full screen on a wide-screen TV monitor, as discussed on page 193.

NOTE: In the 16:9 format, image sizes are smaller than in 3:2 format because the images are cropped to produce the longer/narrower shape, eliminating some pixels. Unless your primary intention is to show photos on a wide-screen TV, you should use the 3:2 aspect ratio. You can later crop any image to the 16:9 ratio before displaying it on a wide-screen TV; save that cropped image with a different file name so that you will also retain the full size 3:2 JPEG for other purposes.

[Quality]: Two options are available for making JPEG images: [Fine] and [Standard]; they are not available when the camera is set for RAW or RAW & JPEG capture. Use the Fine option (lower compression/larger file size/best quality) for most purposes. The Standard option (for higher compression/smaller file size/lower quality) might be useful if your memory cards are almost full and you needed to capture JPEGs of a smaller size. See page 58 for a discussion of the technical aspects of each option and additional comments as to their pros and cons.

In addition to [Fine] and [Standard], this item also allows you to record images in [RAW] only, for photos in the ARW file format, or as [RAW & JPEG]. The latter option will cause the camera to produce a RAW and a JPEG photo simultaneously.

NOTE: When you select RAW capture—with the [RAW] or the [RAW & JPEG] option—the camera always provides the largest RAW image possible, using the maximum megapixel level. In [RAW & JPEG] mode, the camera also sets the largest JPEG size and the Fine quality for JPEG; you cannot change this aspect. Whenever the [RAW] or the [RAW & JPEG] mode is set, the item for [Image size] in the Menu is blacked out, so it cannot be accessed.

HINT: I often use RAW format because of the superior image-enhancing options available in conversion software for this format. Shooting a JPEG plus a RAW file at the same time can be useful if you own an image browser software program that does not recognize the Sony ARW format files; in that case, you would still be able to view the JPEG photo.

[Flash control]: The default setting is **[ADI flash]** (for Advanced Distance Integration), the most sophisticated option for light metering when flash is used. It is available when using Sony lenses, Carl Zeiss ZA (Alpha) lenses, or D-series Konica Minolta Maxxum/Dynax lenses. It will operate with the built-in flash, with Sony HV series flash units, and with Maxxum/Dynax D-series flash units. When a compatible lens and the built-in flash (or an ADI compatible accessory flash) are used, the camera's flash exposure metering system considers data about subject distance in its calculation process.

^ ADI flash metering employs sophisticated technology that often produces pleasing exposures in low light or when flash is used for fill.

If you are using a Maxxum/Dynax lens or flash unit without the D designation, the camera will automatically switch to Pre-flash TTL metering to compensate for the lack of distance information. You can also select **[Pre-flash TTL]**, described in more detail in the chapter on flash

(see page 151), but that's not necessary in most common situations. Sony does recommend that you use Pre-flash TTL instead of ADI flash in certain specific situations, such as when using flash with a polarizer on your lens or when a wide-angle diffuser is attached to the flash unit.

[AF illuminator]: The default setting for this item is **[On]**. When the built-in flash is up, it will fire several short bursts in low light to assist the autofocus system in acquiring focus. You can turn this feature **[Off]** if your friends find the multiple bursts of light annoying while you're taking their pictures. The AF system should still be reliable except in very dark conditions.

[SteadyShot]: This item refers to the camera's built-in image stabilizer, which is set to **[On]** by default to minimize image blurring caused by camera shake. You will probably want to leave it on except when the camera is mounted on a tripod; in that case, turn it **[Off]** with this item, as Sony recommends. Later, when not using a tripod, turn it back On.

[Color Space]: This concept and the value of the two options are discussed on page 75. By default, the α500 and the α550 are set to **[sRGB]**, the optimal color space for viewing images on a computer monitor. You can change it to **[Adobe RGB]** if your primary intention is to make prints with an inkjet printer. Note that many imaging software programs also allow you to change color space for any image, but you should still capture images with Adobe RGB if you know that you will want to make inkjet prints. For other purposes, such as Internet or e-mail use, you would want to convert photos made with Adobe RGB to the sRGB color space with your imaging program.

RECORDING MENU 📷 2

[Long exp. NR]: When this option for long exposure noise reduction is set to its default **[On]**, the camera automatically provides additional processing for images made at a shutter speed of 1 second or longer. That minimizes the visibility of the digital noise pattern, but it definitely slows camera operation (as discussed on page 78). You can set it to **[Off]** if you prefer a more grainy but sharper photo, or want to be able to shoot several frames in a series.

^ If your primary intention is to make inkjet prints, set the Color Space item to Adobe RGB.

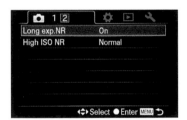

< The file information page contains the file name and the date and time the picture was taken, along with other useful information about the file.

[High ISO NR]: This item is always on; you cannot turn it off. It's set to [Normal] by default in order to provide extra noise reduction processing at ISO 1600 to ISO 12800 to minimize the visibility of the digital noise pattern. You can set it to [High] for more aggressive noise reduction processing; that will produce smoother photos, with very little graininess, but image resolution will be lower. That's because the extra processing smoothes not only the digital noise pattern but the entire image to some extent. Based on my experience, the [High] option should not be used, but you may wish to experiment extensively to determine the exact effect that option will produce at each ISO level from 1600 and up (see page 78 for details on how to do this).

This menu consists of a single page, listing items that you can activate or de-activate to meet personal preferences.

> You will find the
default settings
ideal although a
longer time for
Auto Review may be
useful.

[Eye-Start AF]: By default, this feature is **[On]**, so the camera will automatically activate autofocus and its other systems when it detects your eye at the viewfinder. That is useful, allowing the *α*500 or the *α*550 to offer very quick response to a photo opportunity. Of course, the camera will be fully active whenever anything blocks the viewfinder, such as your hand or leg while carrying the camera; that inadvertent activation can cause needless battery drain. Should that be problematic, turn Eye-Start **[Off]** with this custom item. (This menu item is blacked out when the camera is set for Live View operation, because the optical viewfinder is not available for use.)

[AEL button]: This controls the function of the camera's AEL button. Autoexposure Lock is a feature used to lock an exposure value before recomposing, (as discussed in detail, on page 143). Two options are available. When **[AEL hold]** (the default) is set, the AEL button is active only while you keep it depressed. If you do not maintain pressure on the AEL button, the exposure value will not remain locked.

NOTE: When the camera is set for Multi-segment 🔲 metering, AE Lock is provided by the shutter release button. Maintaining light pressure on the button, after taking a meter reading, ensures that the exposure value—as well as focus—will not change while you recompose. With Center Weighted 🔲 or Spot 🔲 metering however, you would need to use the AEL button if you want to lock exposure after taking a meter reading.

The other option, **[AEL toggle]**, provides an on/off effect. Press the AEL button once and exposure value is locked. It remains locked; there is no need to keep it depressed while you recompose a scene. To turn AE Lock off, press the button again.

> **NOTE:** When the toggle option is set, the exposure lock will not turn off automatically after you take a photo or a series of photos; the locked-in exposure will be used for any subsequent photos until you turn AEL off, or until the camera goes into power saving sleep mode or is turned Off.

The selection of **[AEL toggle]** might be useful in landscape photography to lock the exposure values while you recompose the shot; you won't need to keep the AEL button pressed continuously. However, it can also lead to serious exposure errors if you forget that this option has been set and then forget to turn it off when switching to a different subject, or when the light level changes.

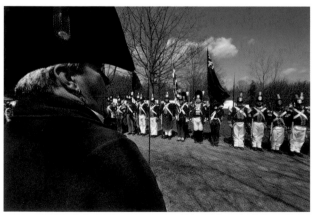

‹ AE Lock is a valuable tool when the focused subject is much darker, or lighter, than a mid-tone.

[Red eye reduc.]: When set to **[On]**, this feature ensures that red-eye reduction is always active when the flash is used. The camera will rapidly fire several bright bursts before the actual flash exposure. If your subjects find the bursts of light to be distracting, that feature can be disengaged by selecting **[Off]**. (Other methods for red-eye control are discussed in detail in the Flash chapter.)

[Auto review]: After you take a photo, Auto review is provided for 2 seconds by default; this allows for quickly checking the photo without consuming a lot of battery power. You can change that instant playback time to [Off] (no auto review will be provided), [5 seconds] (my preferred setting), or to [10 seconds]. Remember, you can examine any image for longer periods of time by using the camera's Playback ► mode.

[Auto off w/VF]: By default, this item is [On], so the camera's LCD screen blacks out as a power saving measure whenever you use the viewfinder. This is a logical setting, but you can also select [Off], forcing the LCD screen to remain active at all times, which can consume unnecessary battery power. (This menu item is blacked out when the camera is set for Live View operation; it's not a relevant item then, because the LCD screen is on at all times since the optical viewfinder is not available.)

[Grid Line]: When the camera is set to Manual Focus Check Live View, a grid pattern appears over the preview image display as an aid to composition and to keeping straight lines straight. This useful feature is [On] by default, but you can turn it [Off].

PLAYBACK MENU ►

Playback allows you to review images on your memory card in the LCD monitor for as long as you want. You can scroll through all of the photos on the memory card. This often helps you determine whether you need to reshoot a particular picture or not. The camera provides several items in a single menu screen.

[Delete]: This setting provides two methods for deleting images from your memory card: either images that you mark for deletion or all images on the card. Use caution with this menu item because deleted images cannot normally be recovered, except with special third-party software.

Select [All images] and press the AF button if you are certain that you want all of the images on the card to be deleted. When the next screen appears, asking if you are certain you want to erase all of the images, scroll up to [Delete] and press the AF button to confirm your decision. If you change your mind, and do not want to proceed, scroll to [Cancel] and press the AF button.

Delete	-	
Format	-	
Slide show	-	
Protect	-	
Specify Printing	-	
PlaybackDisplay	Manual rotate	

◆▶ Select ● Enter MENU ↰

‹ Use the Format item to optimize memory card performance, but note the Caution item below.

If you select **[Marked images]**, you will be able to specify the images to be deleted. After you select this option, the camera allows you to scroll (left/right) through each image on your memory card. When you reach one that you want to delete, press the AF button while viewing that photo. A D symbol will appear to confirm your selection. If you accidentally select a frame for deletion, you can deselect it by again pressing the center button; the D symbol will disappear. You can mark (specify) a few or many images for deletion. After you finish marking, press the **MENU** button, scroll up to **[Delete]**, and press the AF button to confirm your decision to delete the marked images.

[Format]: This item reformats the memory card, permanently erasing all data. Even protected images are deleted. When **[Format]** is highlighted, press the AF button and choose **[OK]** from the confirmation screen. Verify your decision by again pressing the AF button, and a final screen will confirm the formatting activity.

CAUTION: Be sure that you are ready to delete all images; even the best third-party recovery software may not be able to recover any or all images after a card is formatted.

NOTE: Never remove a memory card when formatting is underway, as indicated by a glowing red lamp on the camera back; it could damage your card. I recommend reformattIng the card every time after downloading images to your computer's hard drive or other backup system to keep the card performing at its optimum level. This formatting should always be done in-camera, and not using a formatting option available in a computer because the latter may not properly format the card.

HINT: Should you lose images by inadvertently deleting them, or by formatting the memory card, you may be able to recover the JPEG and RAW photos with third-party software. I use the very effective software available from www.datarescue.com, but you should be able to find others with a Google search using keywords such as Recovery Software Memory Card.

[Slide show]: Press the AF button after scrolling to this item, scroll to the [OK] option and press the AF button again; this will set the camera to provide a slide show of all images on the memory card and will begin on your LCD monitor. Each photo will be visible for three seconds. To pause and restart the slide show, press the AF button. To move ahead or go back quickly, press the left/right controller keys.

To return to normal operation press the MENU button, scroll to [Cancel] and press the AF button. Note too that you can instruct the camera to display each photo for a longer period of time with the [Interval] option. Select the desired period of time after scrolling up to Interval. In most cases five seconds would be an adequate display time for each image. If you want the slide show to repeat continuously, scroll to the [Repeat] option and press the AF button to activate this feature.

[Protect]: This selection allows you to mark images so that they cannot be accidentally deleted. If you want to do so, scroll to the [Marked Images] option and press the AF button. You can now use the controller left/right keys to scroll through the images on your memory card. When you reach one that you want to protect, press the AF button; a O━┓ symbol will appear over the image as confirmation.

> It's worth taking a few minutes occasionally to protect your very best photos.

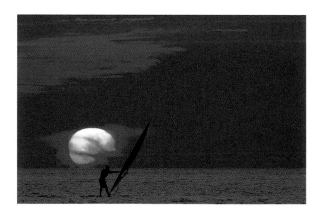

If you accidentally select a frame for protection, you can deselect it by again pressing the AF button; the 🔒 will then disappear. After you finish marking images for protection, press the **MENU** button. On the screen that appears, scroll up to **[OK]** and press the AF button; that will start the protection process. Any protected images will not be inadvertently deleted when you use any of the camera's delete options. However, formatting the memory card will delete all data, including the protected images.

[Specify Printing]: This item provides a few options but its primary function is to allow you to designate JPEGs on your memory card for direct printing using a DPOF (Digital Print Order Format) compliant printer. (You may own such a printer or the printing lab that you use may own DPOF-compliant equipment.) Only JPEGs can be marked for printing. After scrolling to this menu item, press the AF button. The next screen shows **[DPOF Printing - Marked Images]**. Press the AF button if you want to mark a photo; after you do so, DPOF1 appears over that image.

If you want more than one print of that image, press the AF button as often as you wish, and the DPOF number will increase. Then, use the left/right keys of the controller to scroll to another image that you want to mark. When you're finished marking images for DPOF printing, press the **MENU** button.

Note too that this menu item also allows you to activate **[Date imprint]**. It's **[Off]** by default, but if you set it to **[On]**, the date will be printed on the photo when DPOF printing is used with DPOF compliant printers. The date is not printed on the actual JPEG image file, only on the print.

‹ The DPOF functions are intended solely for those who will use a printer or a printing service that is DPOF compatible.

SETUP MENUS

Use the Setup menus to establish or change certain aspects of α500 or α550 operation to meet your own specifications. Three distinct screens are available under the Setup tab, each with its own list of items.

> The Setup menus include some useful housekeeping items.

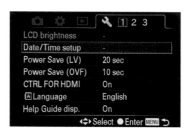

> - LCD brightness ·
> - Date/Time setup ·
> - Power Save (LV) 20 sec
> - Power Save (OVF) 10 sec
> - CTRL FOR HDMI On
> - Ⓐ Language English
> - Help Guide disp. On
>
> ◄◆► Select ● Enter MENU ↰

SETUP MENU ✎ 1

[LCD brightness]: By default, this item is set for **[Auto]**; the camera sets a suitable LCD display brightness depending on the lighting level in the area. Press the AF button and you'll go to the Brightness Setup bar; press the AF button and you can change the setting from **[Auto]** to **[Manual]**.

^ A high level for LCD brightness can be useful in very bright conditions, but remember that the display will not provide an accurate exposure preview.

After setting manual, a +/- scale appears; scroll to the right (toward the plus side) to make the LCD display brighter, to the extent that you want. Scroll to the left (toward the minus side) to make the display darker.

The higher you set the monitor brightness level, the easier it is to see data or images on the LCD monitor in bright conditions. However, setting the brightness to an extremely high or low level makes it more difficult to correctly evaluate exposure (actual image brightness) in Live View or while reviewing images that have been recorded.

[Date/Time setup]: Set the date and time when you first get your α500 or α550, and change them when needed. A screen will display a field for Year/Month/Day; you can modify the data in any of the three fields by scrolling up and down. Fields are also provided for the Hour/Minute/PM or AM, and you can scroll until the correct data appears in each of these fields. This data will not be printed on your images, but it will be recorded for every image and can later be accessed with image editing software.

If you are not happy with the Year/Month/Day format, keep scrolling to the right until the cursor reaches the field at the bottom right corner of the screen. Now, scrolling up/down allows you to change the format for the data to Month/Day/Year or to Day/Month/Year, if you prefer one of those alternatives. Press the AF button after you complete all entries for date/time setup.

[Power Save LV]: By default, the LCD monitor stops displaying data and a preview image when the camera has not been used for 20 seconds. This sleep mode is useful for saving battery power. You can change that to a longer or shorter time with the options in this menu item. A longer time may be convenient, but will increase battery consumption.

This Menu item is not available for selection when the α500 or the α550 camera is in Live View mode. In Live View, the LCD screen also displays a preview of the scene and not merely data; the preview display will not turn off after a few seconds.

[Power save OVF]: When the camera is set for using the optical viewfinder, it will go into power saving sleep mode after ten seconds of non-use. You can change this time to one of several other options, as long as 30 minutes. A 1-minute option makes sense, but allowing the camera to stay on for a very long time when it's not being used will unnecessarily increase battery consumption.

[CTRL FOR HDMI]: This item is relevant when the α500 or the α550 is connected to a widescreen TV with an optional HDMI cable for viewing images on the TV screen. By default, this item is **[On]** to ensure full compatibility with a Sony Bravia TV. If you connect the camera to another brand of television, the remote control unit of the TV may not work properly; in that case, set this menu item to **[Off]**.

NOTE: There is no menu item for setting the camera for video system compatibility for **[NTSC]** (North American standard also used in Japan) or **[PAL]** (Europe and many other countries). That function, available with most cameras, is not necessary because the α500 and the α550 can automatically detect the type of video system in use and make the necessary settings for compatibility.

> The HDMI item may not be necessary and there's no need to set the video format as there is with most other cameras.

[Language]: This item allows you to set a preferred language for all text that is displayed in the LCD screen, including all menu items. Press the AF button and scroll up/down until you reach your preferred language; then press the AF button again to confirm your decision.

[Help Guide Disp.]: By default the α500 and the α550 activate a Help screen with useful info about a function if you wait about a second after scrolling to an item in the Menu or the Function sub menu. That screen also appears when you select an operating mode or use the D-RANGE, Drive Mode, or ISO button to select any options. The guidance is very useful initially, but after a while, you will no longer need it and may find the hint screen to be distracting. In that case, set this item to **[Off]** and

the Help Guide Display will never appear; you can turn it back on when the camera will be used by someone with less experience.

SETUP MENU ✎ 2

[File number]: This menu item manages how the camera will label images in different folders on the memory card. The default setting is **[Series]**. Each time you take a new photo, the file number will be one greater than the number for the previously saved file until 9999 is reached. That is a logical procedure.

If you select the **[Reset]** option, the file numbering will be reset to 0001 when the folder format is changed and when all images in a folder are deleted, whenever you switch to a new memory card, and when you format a memory card. Use this option only if you have a specific reason for doing so. If you select **[Reset]**, the file numbering will restart at 0001 quite often; hence, you will eventually have many images in your computer with the same file number. The **[Series]** option ensures that this will not happen, at least not until after you have taken 9,999 photos with your camera.

‹ Remember to set the USB item to PTP before connecting the camera to a PictBridge-compliant printer.

[Folder name]: This item is used to determine which of two formats are assigned to name folders on the memory card. Each consists of eight characters. **[Standard form]**, the default, creates a label for folders such as 100MSDCF. You may prefer to select **[Date form]**, a format that follows a sequence such as 11190918, which is the folder number plus the year, month, and day. Thus the example above indicates a folder created on Sept. 18, 2009. If you select the **[Date form]** option, a new folder will be created on each day when you make an image with the camera; this is very convenient. All images made that day will be saved in that folder.

CAUTION: Improper cleaning may damage the sensitive filter covering the sensor and require expensive replacement of the entire sensor module assembly. Use extreme care whenever the filter covering the CMOS sensor is exposed. Use a large blower brush (sold by photo retailers) to produce a puff of air to blow away specks. Do not use a can of compressed air because propellant may be sprayed and that can damage the filter. Sony does not recommend the use of sensor cleaning kits (swabs or brushes and liquids) that are marketed by third-party manufacturers. Contact a Sony-authorized service center for professional cleaning if you have trouble removing dust with a blower bulb.

[Pixel Mapping]: This feature can be used if any of the pixels on the LCD screen should fail. A failed or "dead" pixel will show up as a black speck in the LCD display. Do note however, that a dot of that type will not be visible in the image. To remove the dead pixel, start by switching the camera into Live View and putting a cap on the lens. Scroll to the **[Pixel Mapping]** item and press the AF button to proceed; the process will take less than 10 seconds and a confirmation screen will appear when it's finished.

[Version]: This allows for checking the version of firmware (the camera's operating system software) that is currently in use. Scroll to this item and press the AF button. A screen will appear showing the version of firmware that the camera is currently using.

From time to time, Sony may create a new version of firmware; check for that on the Support page of the Sony web site for your geographic region. Should new firmware be available, you can download it into your computer and then into your camera; the Web site will provide full installation instructions. Follow them to the letter to avoid creating problems with your camera.

[Reset default]: This control returns all of the camera features to the factory-set defaults. That includes exposure compensation, metering mode, AF mode, Drive mode, WB, Creative Style, Noise Reduction, and so on. It's useful to activate this reset function after you have been experimenting with many of the camera's many features. (In fact, I did so often while learning to use the cameras' numerous features.) Scroll to this menu item, press the AF button, scroll up to **[OK]** and press the AF button again to activate the reset.

Camera and Shooting Operations

IMAGE SHARPNESS

Various factors contribute to the sharpness of an image. While focus, depth of field, and even use of flash play a role, proper handholding technique is also essential. If you don't use proper technique, camera movement may degrade image sharpness and your pictures will be disappointing. A good way to evaluate your technique is to review your photos. If the focused subject is not crisp, but another element in the scene is sharp, the problem is usually caused by an improperly focused image. However, if nothing in the photo is tack sharp, the cause is probably camera movement.

Long lenses, especially, are often heavy and difficult to hold steady. Just as telephotos magnify the subject, longer lenses magnify the effect of any camera movement. A rule of thumb suggests that your shutter speed should approximate the reciprocal of the effective focal length of the lens in use to make sharp photos. For example, a 100mm equivalent lens would require a hand-held shutter speed of about 1/125 second, while 500mm equivalent would require at least 1/500 second. (When considering this, remember that due to the size of its sensor, the 35mm equivalent focal length of a lens on the α500 or the α550 is the actual focal length multiplied by 1.5) If you cannot achieve a high enough shutter speed at your desired aperture setting, you can increase your ISO, but beware of digital noise at ISO 1600 and especially at higher ISO levels. If you want to shoot at long shutter speeds, use a tripod or other camera support.

HANDHOLDING TECHNIQUE

Proper technique will maximize the odds of a sharp photo when handholding the camera. Hold the camera's grip in your right hand with your index finger on the shutter button. For horizontal (landscape format) pictures, cradle the lens and body in your left hand so that your fingers can comfortably operate the lens if necessary. For vertical (portrait format) shots, turn the camera so your right hand is on top and the opposite end of the camera is cradled in your left hand. With either format, keep your elbows in, pressed gently against your body for additional support. Spread you legs apart in a firm, but comfortable, stance. When you are ready to take a picture, exhale and roll your finger across the shutter button, making sure to hold the camera level.

▁▃▅ THE STEADYSHOT SYSTEM

Sony has incorporated an improved version of its anti-shake technology into the α500 and α550; it's set to On by default. Unlike some other manufacturers' stabilization systems, which work by shifting elements within a lens, the SteadyShot device shifts the CMOS sensor inside the camera body. This provides image stabilization with virtually all

∧ As these photos (with and without the stabilizer at a 1/8 second shutter speed) indicate, Sony's SteadyShot system is very useful when you must shoot in low light without a tripod.

Maxxum/Dynax lenses, all Sony lenses, and the Carl Zeiss ZA series marketed by Sony. It should also work with aftermarket brand lenses with the appropriate mount.

The system consists of a sensor that detects motion and a mechanical device. When the in-camera sensor detects motion, a microcomputer analyzes data on focal length, aperture setting, and focusing distance and sends a signal to a motor which mechanically shifts the sensor unit to compensate. The incoming light rays are refracted and the projected image is returned to the center of the frame, which produces a sharper image.

The SteadyShot stabilizer is designed primarily for handheld use at shutter speeds faster than 1/4 second. When the system is active, a scale ▂▃▄ featuring five distinct bars, is displayed in the viewfinder data panel and in the LCD panel. During stabilizer operation, one or more bars will be illuminated. Whenever all five bars are visible, there is a greater risk that the image will be blurred to some extent by camera shake. When the «🖐 icon is also displayed, the risk of blurring is even greater; brace the camera or your elbows against some solid object to minimize camera shake.

NOTE: The SteadyShot stabilizer is not fully active when the camera is first turned on or when it first wakes from power-saving Sleep mode. Initially, five bars are illuminated indicating that the system is not yet fully effective. After about one second, you may find that fewer bars are visible; that confirms full stabilizer effectiveness. In low light, when using a long shutter speed, all five bars may be continuously illuminated; that is a warning that the system is working to its maximum ability. In bright light, the scale may not appear at all; that is an indicator that the shutter speed in use is adequately fast, requiring no image stabilization activity.

STABILIZER OPERATION

Sony indicates that the SteadyShot stabilizer system should allow you to handhold the camera at up to 4 shutter speed stops longer than the rule of thumb suggests. Take a conservative approach to be sure of getting photos without blurring from camera shake. Stay within 2 stops of your normal minimum hand-holdable shutter speed. Use even faster shutter speeds if practical, especially if maximum SteadyShot activity is denoted by five bars in the ▁▄█ indicator scale. You may decide to exceed this recommendation, using even longer shutter speeds, especially if you're particularly steady when handholding any lens or if faced with an "all or nothing" shooting situation.

With large, heavy telephoto lenses, use a tripod. Sony recommends you disengage the SteadyShot system whenever you use a tripod. (The stabilizer was not designed for effectiveness when a tripod is used.) When shooting from an unstable platform, such as a boat, activate the stabilizer system and use fast shutter speeds: at least 1/60 second with a 28mm focal length and at least 1/500 second at the 300mm end of a zoom lens.

NOTE: Be aware that the SteadyShot system does use battery power. While the camera's battery will still last for a very long time, take an extra battery if you plan on shooting with SteadyShot a great deal during a long day's outing.

QUICK AF LIVE VIEW

Although traditionalists may prefer to use the optical viewfinder, Live View is also available for composing images on the LCD monitor. In order to use this feature's primary function, flip the switch on the camera's right shoulder from OVF to the Live View position. That will activate Quick AF Live View, providing a real-time preview of the scene on the LCD monitor.

Sony was not as quick as some manufacturers to equip their D-SLR cameras with a Live View feature. That was because the company's engineers were still developing the technology required to provide very fast autofocus in Live View, without interruption of the real-time preview display. Sony developed a unique method to achieve that goal. When you flip the switch from OVF to Live View with the α500 or the α550, a small mirror inside the viewfinder tilts, directing light to a secondary imaging sensor. That sensor provides a real time preview image of the scene on the LCD monitor. Meanwhile, the reflex mirror can remain in the down position; it does not flip-flop up and down so the LCD screen never blacks out during autofocus operation. A secondary mirror directs light to the AF sensor for remarkably fast autofocusing using the so-called phase detection technology.

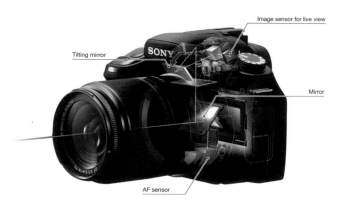

∧ This diagram illustrates the operation of the Quick AF Live View system, which generates an image preview from a smaller, secondary sensor. © Sony

In this Live View mode, autofocus is very fast because the AF sensor is constantly receiving light; it's even faster than with earlier α cameras thanks to some technical improvements. Hence, the camera can focus and take a photo quickly to capture a fleeting instant. Naturally, the reflex mirror must flip out of the light path to allow the camera to take a photo so the LCD screen does black out, but the live preview resumes after about a second.

Because the α500 and the α550 employ a secondary sensor to provide the real-time preview in Quick AF Live View, the LCD shows only 90% of the actual image area that will be captured. The display is not fully accurate in terms of the actual exposure and white balance, although it's close enough for most casual picture-taking. Note too that selecting Live View causes the camera to switch from 40-zone metering to a more sophisticated system that measures brightness in 1200 zones. That is intended to produce a more accurate exposure in difficult lighting conditions.

⌗ SMART TELECONVERTER

When the α500 or the α550 is set for Quick AF Live View operation and JPEG capture, an extra feature (unique to Sony) is available. Press the Smart Teleconverter ⌗ button and the camera automatically boosts magnification by 1.4x; press the button again and 2x magnification is provided. This feature makes a distant subject seem to be closer—larger in the frame—as if you were using mechanical 1.4x or 2x teleconverter accessory, discussed in the Lenses chapter.

However, it's important to note that this electronic function works by cropping the image, discarding all but the central part of the photo. While that does make the subject seem larger or closer, the process also discards numerous pixels, reducing effective resolution. Image quality will remain excellent but the JPEG file will contain fewer pixels (especially when the 2x magnification is used) so you will not be able to make very large prints; the same applies if you crop a photo with image editing software, of course.

The Smart Teleconverter function can be useful for photos that you plan to print direct, using a PictBridge compliant printer, without any adjustment in a computer. Unless that is your specific intention, it's preferable not to use the Smart Teleconverter. Instead, record the full photo even if the subject seems small in the frame. Later, crop it with image editing software. That alternative will provide greater versatility, allowing you to achieve the exact cropping that's ideal for any particular image.

MANUAL FOCUS CHECK LIVE VIEW

The α500 or the α550 can also be used in this second mode that is primarily intended for use when the camera is on a tripod. Press the MF Check LV button and the real time preview will be superior in resolution as well as brighter and less "grainy" in low light. The preview display will also be more accurate in depicting the actual results that a change in ISO, White Balance, and Creative Style settings will produce.

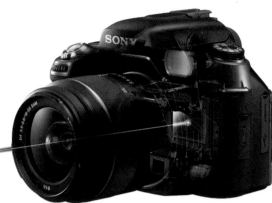

> As this illustration indicates, the Manual Focus Live View system provides the real-time preview display from the large CMOS capture sensor and not from the secondary sensor as in Quick AF Live View. © Sony

NOTES: Any exposure compensation setting made with the camera in either Live View mode will not make the display any darker or brighter; however, the compensation will affect the actual image that is recorded by the camera. After taking a photo when using MF Check Live View, the camera will revert to the conventional Quick AF Live View mode. If you want to use MF Check Live View for the next shot as well, simply activate it again.

When you press the MF Check LV button, the camera's reflex mirror flips up and the live preview display is provided by the large, ultra-high resolution CMOS sensor. (In Quick AF Live View, a tiny secondary sensor, with lower resolution, provides the preview image.) The extra brightness makes it more useful for checking composition and fine detail especially in low light conditions.

THE FOCUSING SYSTEM

The α500 and the α550 are equipped with a sophisticated TTL phase-detection autofocus (AF) system to assure quick, accurate focusing in almost all picture-taking situations. It utilizes nine focus detection points including a cross-hatched center point. The location and angle of each focus detection point—called Focus Area by Sony—is denoted on the viewfinder screen. The central point is the most sensitive because it reads both vertical and horizontal patterns.

The AF system functions in light that is the ISO 100 equivalent of 0 EV to 18 EV (which in layman's terms, means from low light to very bright conditions). When you set the camera to OVF, Sony's Eye-start system activates autofocus the instant it detects your eye at the viewfinder, making focus acquisition particularly fast. There is also an AF illuminator feature, available with the built-in flash and accessory flash units; this helps the camera to focus in low light when using flash.

AF MODES

The α500 and α550 offers three autofocus modes. To set the desired autofocus mode, make sure to flip the AF/MF switch (on the front of the camera)—or on a lens with an AF/MF switch—to the AF position. Then press the **Fn** button to access the Function sub-menu; scroll to the AF Mode item, press the AF button and scroll to one of the following three options. Press the AF button to confirm your selection.

AF-S Single-Shot Autofocus: This mode is intended for static subjects. Activate autofocus with a touch of the shutter release button. (If Eye-Control is on, the camera will activate AF as soon as you look through the viewfinder.) During autofocus operation, the 《》 symbol will appear in the viewfinder data panel. When focus is acquired, the focus detection point that found focus will light in red on the viewing screen; the focus confirmation ● signal will appear as a solid dot and the camera will beep as confirmation. As long as slight pressure is maintained on the shutter button, focus remains locked; you can now recompose without changing focus if desired (this act of gaining focus on an AF point and moving that point over a different subject is known as focus lock).

When the camera is used in Quick AF Live View, a green rectangle lights up on the LCD display to confirm the part of the scene that is in sharpest focus. The focus confirmation ● signal also appears below the image display area as a solid dot and the camera beeps as confirmation. If the AF system cannot find focus, the ● dot will blink in the viewfinder data panel or at the bottom of the LCD screen in Live View mode. You cannot take a picture until focus is confirmed.

NOTE: When the camera is set for Multi Segment ▣ metering, maintaining light pressure on the shutter release button not only keeps focus locked but also keeps exposure locked. Neither focus or exposure will change as you recompose for different framing. That allows for optimizing both focus and exposure for your primary subject. Should you switch to one of the other metering patterns, exposure will not be locked automatically when focus is locked; you would need to use the AEL button as discussed on page 143.

AF-C Continuous Autofocus: This mode activates full-time tracking focus. Focus is never locked, but shifts continuously as the camera-to-subject distance changes. Focus lock is not available; if you recompose, focus will change. (Some Maxxum/Dynax and Sony telephoto lenses incorporate a focus hold button that allows you to lock focus in AF-C mode.) The active AF area that finds focus will be illuminated in the viewfinder or on the LCD display in Live View. A 《》 symbol will also appear confirming focus but the camera will not beep. The flash unit's focus-assist feature will not operate in AF-C mode. If focus cannot be acquired in AF-C mode, the camera will not allow you to take a photo; the focus confirmation dot ● will blink in the viewfinder and LCD data panels.

AF-C is ideal for action photography because tracking focus starts instantly without the delay that occurs in AF-A mode when the camera must switch between AF-S and AF-C. The system is most reliable (virtually foolproof) in brightly lit outdoor photography. Like any AF system, it's not quite as fast in very low light.

AF-A Automatic AF Mode Switching: In this mode, the AF system switches automatically from Single-shot AF to Continuous AF mode if the system detects subject motion: the subject moving closer to the camera or away from the camera. This is the default mode and it's

recommended for multi-purpose use. With static subjects, AF-A mode works exactly like AF-S mode.

When subject motion is detected, the AF-A system switches to using AF-C mode in order to track the subject's progress. This option is particularly useful for subjects that are static but might begin to move soon. Response to motion may take a second or two as the AF system recognizes the change and adjusts for tracking the moving subject. Hence, the first shot or two in a series may not be perfectly focused.

> Both the Focus Mode and AF Area Selection items are available in the Function sub-menu. Scroll to the desired item and press the AF button to reveal the available options.

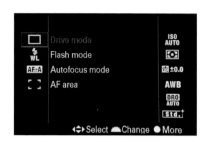

AF AREA SELECTION

The autofocus system is equipped with nine focus detection points—called AF areas by Sony—in order to find focus. The location of each point is marked on the viewing screen as small rectangles. You can select among three focus point selection options with the AF Area item in the Function sub-menu.

Wide AF area: This is the camera's default mode. All of the system's focus points are active and the camera uses automated focus point selection. Focusing is completed when one or more of the nine points finds focus. The active focus point (or points, when the scene includes several objects at the same distance from the camera) are then illuminated in red on the viewing screen.

The automated system cannot read your mind, so it will not always use the focus detection point that covers your intended subject. In a scene with several objects, the system may select the closest subject or the object with the greatest contrast or most distinct texture. With "difficult" subjects—those with unusual patterns, for example—the central focus point (or AF area) will often set focus so that the object in the center of the frame will be sharpest. This is because the central focus point is cross-

hatched—it includes both horizontal and vertical sensors and is capable of acquiring focus even with subjects that may hinder the other focus detection points.

The Wide AF area option, with its automated focus point selection, is often used for action photography because it can focus on off-center subjects. It also works well for snapshots or point-and-shoot photography. Naturally, the system will not always produce the intended effect, possibly focusing on a secondary element that's closer to the camera or is a more reliable target than your preferred subject.

NOTE: While using the Wide AF area, you can switch at any time to using only the central focus detection point—called Spot Focus. Simply press the AF button in the center of the four-way controller and the camera will instantly focus using only the central point. After you take the photo, it will automatically revert to the standard wide area AF approach. This feature is useful in the situation described above, where the AF system sets focus on a secondary element instead of your primary subject.

Spot AF Area: When you select this option, the camera will employ only the central focus detection point; the other eight points will not be active. Target your subject and lock focus by keeping the shutter button pressed halfway while recomposing. The central focus detection point is more reliable in low-light photography than any of the other points. As well, Spot AF area is useful in action photography—when the subject is large or located in the center of the frame—in combination with the AF-C mode. Because the central focus detection point is the most sensitive, it is the most reliable in quickly focusing on an approaching subject, such as a galloping horse or a race car.

Local AF area: In this mode, you can select any of the nine focus detection points—or local AF areas—and you can change the active point at any time. Use the Controller keys to select one of the outside focus areas while looking at an off-center subject through the viewfinder. Once a focus point is selected, it will be briefly illuminated in red on the viewing screen when it finds focus. To quickly select the central focus point, press the AF button in the center of the controller.

The ability to manually select any of the several focus detection points is common to many brands of D-SLRs. This feature certainly sounds useful and logical. However, unless I'm taking many photos of a static subject that is off-center, I'll

generally use only the central focus area, often with focus lock. Nevertheless, you may find circumstances where you'll want to select one of the other eight "local" focus area points, and that option is certainly available to you.

😀ON *FACE DETECT AND* 😊ON *SMILE SHUTTER AF*

When the camera is set for Quick AF Live view mode (with the OVF/LIVE VIEW button) Face Detection 😀ON Autofocus is on by default. When the AF system detects a face, or several faces in the scene, it will prioritize its calculations accordingly. Focus, exposure, white balance, flash output, and other variables will ensure that your subject's face is appropriately rendered in the photo. When a face (or several faces, up to eight) are detected, an orange square appears over each face on the LCD screen display to confirm that Face Detection has been succesful. Press the shutter release button and the square turns green before you take the photo.

∧ The Face Detection system 😀ON optimizes focus and exposure for a person or persons in a scene. When Smile Shutter 😊ON is also activated, the camera will take the shot automatically as soon as the subject smiles.

The Face Detection system also offers a Smile Shutter 😊ON function. When this is set to On in the Function sub-menu—and when a face is detected by the AF system—the camera will automatically take a photo when your subject smiles. This feature is also straight-forward and intuitive. You can set the sensitivity of this feature by scrolling to

the right from the Face Detection item in the Function sub-menu. You can instruct the system to take a photo when the smile is Big, Slight, or Normal. (By default the system seems to be set to a Normal level.) Face Detection works even if you focus on a photograph of a smiling person.

MANUAL FOCUS

To use manual focus, set the AF/MF switch (either on the camera, or on certain lenses) to the MF position. This disengages the autofocus system so you can focus manually at any time using the focus ring on your lens. If you are having trouble focusing in dark locations, or you want to set focus in anticipation of an event, you can estimate the subject distance and set the focus accordingly. (Of course, this works only with lenses that include a focus distance scale.)

NOTE: In the MF Check Live View mode (discussed earlier in this chapter), you must use manual focus. Autofocus is not available. If you want to use Live View with autofocus, change to the Quick AF Live View mode with the OVF/LIVE VIEW switch.

When focus is correct, the focus signal ● in the data panel lights steadily. However, when focusing manually, you can take a picture anytime, even if focus is not confirmed.

I recommend switching to MF occasionally, especially in landscape and architectural photography. The full-time manual option is also ideal for critical focus on a small, specific subject element: the eyes in a portrait or the stamen in the heart of a blossom, for examples. Finally, manual focus is a very conventional but convenient method for focusing on one segment of a scene while setting exposure for an entirely different area. Focus on a bride in white for example, but use the AEL feature to meter and lock the exposure value from a mid-tone, such as grass in the same light as the subject.

DRIVE MODES

The function of the Drive modes is similar to that performed by the motor drive in a film camera. While no film has to be transported, these modes control the firing and resetting of the camera's shutter mechanism.

In any one of the P, A, S, or M operating modes, set the Drive mode by pressing the button ⟳ / ⧄ (on the camera's right shoulder) or in the Function sub-menu. Use the controller keys to scroll to a desired option and confirm your selection by pressing the central button.

> The cameras provide many Drive mode options; initially, you will see these three options, but scroll down and others will be visible.

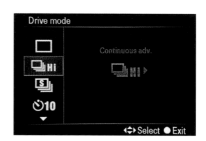

☐ SINGLE-SHOT ADVANCE

The default Drive mode, Single-Shot advance, causes the camera to take one photo each time you press the shutter button. Select this option when you simply want to shoot a single image at a time rather than a series in a bracket or a burst.

⧄Hi CONTINUOUS ADVANCE

In Continuous advance, the camera will keep recording images, at up to 5 frames per second (fps), or 4 fps in Live View, as long as the shutter button is held down. This is useful when you want to shoot a series of images, whether it's friends being silly or action at a sports event. For the fastest available framing rate with either camera, the shutter speed must be 1/250 second or faster. If slower shutter speeds are used, the framing rate will be slower. If you scroll to the right from the ⧄Hi icon for the Lo option ⧄Lo; a lower-speed continuous Drive mode is available.

NOTE: The framing rate can be quite slow when flash is used because the flash must recycle after each image in order to fire again. The recycle time depends on the amount of flash output used when making an image. There's a long recycle time when high output is required (great flash-to-subject distances), and a quick recycle time when lower output is required (with nearby subjects or in bright light).

⌨ *SPEED PRIORITY*

Available as a Drive mode item only with the α550, Speed Priority continuous advance provides a 7 fps drive speed. Do note, however, that focus and exposure are set when the first photo is taken. Neither aspect will change even if you recompose to frame another subject at a different distance and in different light while shooting a series of photos. Autofocus will not track the subject if it moves closer to the camera or moves away from your position. These limitations were required in order to allow the α550 to fire at such an unusually high speed.

∧ The Speed Priority mode is useful for taking a series of photos in situations where the camera-to-subject distance, and the lighting, remain constant.

The Speed Priority Drive mode is most suitable for a static subject. For example, you might use it to record a series of photos of a friend's golf swing or the feeding activity inside a bird's nest. As long as the camera-to-subject distance and the brightness of the lighting do not change while you shoot the series, every photo should be just fine in terms of focus and exposure. For most action photography, however, be sure to use the standard Continuous advance ⌨Hi Drive mode.

⏱10 *10SEC SELF-TIMER*

When this option is selected, the camera waits 10 seconds after the shutter button is pressed before it fires. This can be useful when the photographer wants to get into the picture and when the camera is mounted on a tripod. Focus and exposure are set when you first press the shutter button. If the lighting changes during the 10-second delay, the exposure may not be correct.

⏱ 2 *2SEC SELF-TIMER*

Selected by scrolling to the right from the ⏱10 item, this option provides only a 2-second delay between pressing the shutter and when the shutter actually fires. This option may be used for tripping the shutter when using long shutter speeds, or telephoto or macro lenses, while the camera is on a tripod. This way a photo can be taken without touching the camera and creating vibration. Focus and exposure are set when you first press the shutter button, so it is best used with fairly static subjects.

HINT: If you photograph birds or animals, it's best to use one of the optional remote control accessories, RM-S1AM (short) or RM-L1AM (long), or the wireless remote controller RMT-DSLR1. One of those accessories will enable you to trip the shutter at exactly the right instant without the delay caused by the self-timer without jarring the camera.

In addition to the basic Drive modes, the Drive mode feature also provides Exposure Bracketing options (see page 142) and White Balance Bracketing options (see page 68). A Remote Commander ▣ mode is also available; that should be set only when using an optional Sony RMT-DSLR1 wireless remote controller accessory.

EXPOSURE: THE BASIC CONCEPTS

Before moving on to consider camera features regarding exposure, let's briefly consider the most important concepts. The term "exposure" in digital photography is defined as the amount of light that is required to create a likeness of the subject on the camera's sensor. Ideally, the exposure should be "correct." This means the image should depict the scene with pure whites, rich, dark blacks, and mid-tones that are not excessively light or dark. Important detail should be visible in both highlight and shadow areas.

Every camera's light metering (or measuring) system is calibrated to provide ideal exposure with average or mid-tone subjects such as grass, rocks, trees, or a gray card. When you use a very basic, conventional system, exposure errors are likely when the subject is very light in tone, such as a scene with bright snow, sand, sky, or water. In that case, the image may be too dark or underexposed. Conversely, a subject that is very dark in tone, such as a black lava field, may cause the photo to be too bright or overexposed.

Two factors control the amount of light that produces the image: the length of time that the camera's shutter is open and the size of the aperture (opening) in the lens. The selection of shutter speed and aperture can be left entirely to the camera, or it can be managed by the photographer using the camera's various exposure modes.

THE ROLE OF SHUTTER SPEED AND APERTURE

In order to create an image with the desired amount of light, the correct combination of shutter speed and aperture must be selected. This ensures that the image is not excessively bright or excessively dark. The longer the shutter speed, the greater the amount of light that will strike the image sensor. The larger the aperture selected, the more light that will enter during any given exposure time.

Shutter speeds are denoted in seconds, or fractions of a second. Aperture size is denoted with f/numbers, also called f/stops. The smaller the f/number, the larger the aperture size. A wide aperture such as f/4 will allow far more light to enter the camera than a small aperture such as f/16 during any time duration the shutter is open. In a fully automatic mode, the camera's exposure metering system considers scene brightness and sets an f/stop and shutter speed that should produce

a well-exposed image. In a semi-automatic mode, you can select the aperture (A mode) or the shutter speed (S mode) and the camera will set the other factor; again, this should provide a well-exposed image.

NOTE: Even the most sophisticated light meter—such as the 40-segment system—will not always produce a perfect exposure. Extremely light or dark-toned subjects may cause exposure errors. Also, an accurate exposure may not be the most pleasing or most appropriate for creative expression. That's why the α500 and α550 include options for adjusting the exposure as discussed in this chapter.

EQUIVALENT EXPOSURE

The camera's shutter speed and aperture steps (or stops) both increase and decrease exposure in equal amounts. Each full step increment doubles or halves the amount of light reaching the sensor. Thus, if you are using the Manual mode, you can decrease the length of the shutter speed by one full stop and increase the size of the aperture by one full stop so the exposure will remain the same.

In Aperture Priority (A) mode, you can change the aperture (f/stop) to alter the depth of field (see page 128 to learn about depth of field); when you do so, the camera will change the shutter speed accordingly to maintain the same—or equivalent—exposure. In Shutter Priority (S) mode, you can change the shutter speed to influence the rendition of motion. If you do so, the camera will change the aperture (f/stop) to maintain the same (equivalent) exposure.

SENSITIVITY OR ISO

The amount of light required for an accurate exposure depends on the ISO setting you have selected on the camera. ISO is an international standard for quantifying a film's sensitivity to light. While digital cameras do not use film, ISO numbers are still used to set the sensor's sensitivity to light. A low ISO number, such as 100, expresses low sensitivity to light. High ISO numbers like 800, 1600, or especially 6400 and higher, denote increased sensitivity to light. This factor is automatically taken into account by the camera's light meter when making calculations about the aperture and shutter speed combination that should produce a good exposure.

NOTE: ISO numbers are mathematically proportional, as are shutter speeds and f/stops. As you double or halve the ISO number, you double or halve the sensitivity (i.e. at ISO 800, half as much light is required than at ISO 400; and at ISO 800, twice as much light is required compared to ISO 1600).

The α500 and α550 allow you to set an ISO from 200 to 12800, although you will rarely need to use an ISO above 1600. Digital noise (a grainy effect characterized by mottled specks of color) increases at higher ISO levels, particularly at ISO 3200 to 12800. Select ISO 200 for the best image quality, and higher ISO levels as needed for faster shutter speeds in low light or to "freeze" a moving subject.

By default, the ISO feature is set to AUTO (not to be confused with auto exposure mode). This is an automatic ISO selection feature that allows the camera to make its own ISO settings between 200 and 1600; it will set a low ISO in bright light and a higher ISO in darker conditions. The higher ISO will allow for faster shutter speeds, in order to minimize the risk of blur from camera shake or subject motion. (The SteadyShot stabilizer is useful for minimizing the effects of camera shake, but it cannot compensate for subject movement or for camera shake at extremely long shutter speeds.)

DYNAMIC RANGE OPTIMIZER AND AUTO HDR

Although technically not considered an exposure control, the D-Range Optimizer (or DRO) and Auto HDR features do affect the brightness of certain parts of an image. (They were not intended as an alternative to exposure compensation, but rather for solving technical problems in harsh lighting conditions.) These features are available as options in the Drive mode and were mentioned briefly in the Digital Recording chapter, but let's take a closer look at each of them.

THE DYNAMIC RANGE OPTIMIZER (DRO)

The Dynamic Range Optimizer (DRO) is an extra processing feature provided by the camera's BIONZ engine and creates images with an optimized level for exposure and contrast. The default setting (in most operating modes), DRO Auto, provides a moderate lightening of

shadow areas without lightening highlight areas. For example, a scene may include a very bright sky and a darker landscape or a person posing on a beach against very bright water. When DRO Auto 🖼 is active—as it is by default in P, A, and S mode—the processing will lighten the shadow areas for a more pleasing overall exposure.

NOTE: The camera activates one of the DRO options in some, but not all, of the Scene modes. User control of the DRO function is only available when the camera is set to P, A, S, or M mode. However, in M mode, only DRO with Levels selection 🖼 is available.

Scroll to the right from that mode and you get Levels control 🖼, from Lv 1 for a minor change to Lv 5 for a dramatic increase in shadow detail. The processor will also darken extremely bright highlight areas, making detail or texture more visible. The result of DRO can vary from subtle to obvious.

Try experimenting—especially in scenes of high contrast, including both dark shadow areas and very bright highlight areas. A scene of this type may be a landscape photo or a person who is backlit, posed against a sky with huge white clouds. Take the same photo with each level of DRO: Auto and then Lv 1 to Lv 5. Later, examine the six images on a large computer monitor. You should find that the effect produced by DRO Auto is minimal. You may find that the effect produced by Level 4 and 5 is excessive; the images may no longer look natural. In most cases, I find that DRO Level 2 produces the best results under harsh, high-contrast lighting. It provides highlight and shadow areas with just the right amount of detail and an overall natural-looking effect.

🖼 HDR (HIGH DYNAMIC RANGE)

This is a unique feature that causes the camera to take two JPEG photos quickly, each with a different exposure setting. (One photo is exposed to optimize shadow detail and the other is exposed to optimize highlight detail.) The BIONZ processor automatically combines the two frames to provide a single image with a high degree of detail in both shadow areas and highlight areas. That processing is very quick, taking less than two seconds. (HDR is not available in RAW or in RAW & JPEG capture mode.)

∧ The Dynamic Range Optimizer can be useful in high-contrast scenes, especially with levels control. The first photo was made without DRO while the subsequent photos were made using DRO Auto, DRO Level 2, and DRO Level 5 respectively.

synchronization speed: 1/160 second. (With certain flash units, High Speed Sync is available, allowing for flash photography at much faster shutter speeds.)

NOTE: In the A and S modes, it is possible to select an aperture and/or shutter speed that will produce an incorrect exposure and the camera will display an Exposure Range Warning. That can occur when you set a very small aperture (such as f/22) or a very fast shutter speed (such as 1/1000 sec.) in low light, especially when using a low ISO level. It can also occur in very bright conditions when you set a very wide aperture (such as f/4), especially while using a very high ISO level. Fortunately, the camera provides an advance warning when your settings are likely to produce an exposure error (an excessively dark or bright image). The aperture or shutter speed numeral blinks in the viewfinder data panel or on the LCD screen if shooting in Live View. When that occurs, change the aperture, shutter speed, and the ISO level until the blinking stops.

The following section goes into detail about understanding and manipulating depth of field. This information appears here because it is a topic closely associated with selecting aperture settings. If you prefer to skip ahead and continue reading about the exposure modes available on the α500 and the α550, this topic resumes on page 131 with Shutter priority.

Depth of Field: A Short Course: While the elements in your photos are usually three-dimensional, they are recorded on the sensor in two dimensions with a single plane of sharp focus. In other words, if you focus on a subject that is 10 feet (3 m) from the camera, everything at the same distance will be sharply focused. Everything at different distances will appear less sharp.

However, when an image is viewed (as a print or on a monitor) there is an area in front of and behind the plane of sharp focus that is perceived to be in focus. This range of apparent sharpness is referred to as the depth of field. The factors that influence the amount of depth of field are:

O The focused distance
O The focal length in use
O The shooting aperture

If the focal length and subject distance are constant, depth of field will be shallower with large apertures (lower f/numbers) and more extensive with small apertures (higher f/numbers). If the aperture and focused distance are constant, depth of field will be shallower with longer lenses (telephoto range) and more extensive with shorter lenses (wide-angle range). If the focal length and aperture are constant, depth of field will be greater at longer focused distances and shallower with closer focused distances.

∧ The out-of-focus background in this photo indicates very shallow depth of field. This effect was achieved with close focusing, using a 60mm focal length, and a very wide aperture of f/4.

Today's cameras use open-aperture metering. This means that they don't close down the aperture to the shooting aperture until a split second before the shutter opens to record an image. Until then, the aperture stays wide open, allowing the viewfinder or the Live Preview display to be as bright as possible for composing and focusing. This does cause one problem, however: viewing a scene through the lens' maximum aperture doesn't allow you to judge depth of field at the actual shooting aperture.

The more expensive high-end Sony Alpha D-SLR cameras include a feature that closes the lens to the selected aperture so you can preview the depth of field as it will appear in the finished photograph. This feature

is not available with the α500 or the α550, which are more affordable cameras. Hence, you cannot preview the actual depth of field at any aperture. This is not generally a huge problem as long as you remember that wide apertures (such as f/4 or f/5.6) provide shallow depth of field and small apertures (such as f/16) provide more extensive depth of field. When getting the exact effect is important, take the same shot using several different apertures; one of the images should be just right.

^ This image was taken with a very small aperture, f/22, and is sharp from foreground to background, indicating very extensive depth of field.

When the α500 or the α550 is used in Quick AF Live View mode (as discussed on page 109), the preview image on the LCD screen will show some difference in depth of field at various apertures. If you want a better view of actual depth of field, set the camera to Manual Focus Check Live View. In this mode, the preview image display is provided by the camera's large CMOS sensor so you can see exactly what will be recorded in the photo. In Quick AF Live View, the preview is provided by a small secondary sensor so the display is not accurate in terms of depth of field and the display quality is less clear and crisp.

Depth of Field Shooting Tips: In close-up photography, the range of acceptable sharpness is limited. To maximize it, choose a small aperture such as f/16. You may also wish to control the point of focus to further maximize depth of field. (Remember that focused distance is part of the depth of field formula that is especially important at close ranges.) If depth of field is not adequate, you can use a smaller aperture, or readjust the point of focus. For example, when photographing a flower, you may find that overall sharpness will be improved by focusing on a different part of the flower.

A soft, out-of-focus background is preferred for portrait photography because it will not draw the viewer's eye away from the subject. To accomplish this, choose a large aperture (small f/number, such as f/4 or f/5.6). Because telephoto lenses have less inherent depth of field than shorter focal lengths, they are ideal for isolating the subject against a softly blurred background.

For landscape photography, maximizing depth of field will render more of the scene in focus. Besides using a small aperture (such as f/16), controlling the point of focus will make the most of the depth of field. As a rule of thumb, depth of field will extend about 1/3 in front of the point of focus and 2/3 behind it. Thus, focusing roughly a third of the way up from the bottom of the frame will yield the greatest range of acceptably sharp focus. Take advantage of the lens or focal length to create a pleasing scenic view. Not only does a wide-angle lens allow you to capture sweeping vistas, but it also maximizes the depth of field in the photograph.

SHUTTER PRIORITY (S)

When you want to control how motion is rendered in a photo, switch to the camera's S mode. This semi-automatic mode allows you to select a shutter speed, and the camera will set the appropriate f/stop for a suitable exposure. In some cases, exposure compensation will be required for a perfect exposure. Also remember the Exposure Range Warning; if you set a totally inappropriate shutter speed, a serious exposure error can occur.

When using flash in S mode, the camera will allow you to select a shutter speed as long as 30 seconds. If you try to set a shutter speed faster than 1/160 second, the camera will override and revert to the maximum flash sync speed. (With certain flash units, High Speed Sync is

available, allowing for flash photography at much faster shutter speeds.) All camera functions and overrides are available in S mode. Flash will always fire when it is popped up or when an accessory flash unit is on, even in bright scenes.

The following chart may be useful as a tool for learning the meaning of many common shutter speed abbreviations that you are likely to encounter in any camera exposure mode. It does not include every available option, but once you understand the concept, you'll have no difficulty in determining the exact shutter speed.

o 1000: 1/1000 second
o 60: 1/60 second
o 1": 1 second
o 1"5: 1.5 seconds
o 15": 15 seconds

Shutter Speed Considerations: Aside from using a shutter speed that will produce a sharp photo without blur from camera shake, there is another important reason for selecting a slow or fast shutter speed: the ability to control how motion is portrayed in the photo. To appreciate the concept, take several shots of moving cars at a fast shutter speeds such as 1/500 or 1/1000 second. Do the same at a slow shutter speed such as 1/15 second. Analyze the resulting images and you should find that the first set is quite sharp while the second depicts the subject with motion blur.

> A long shutter speed, 1/5 second in this case, can be useful for producing an impression of motion in a still image. In order to prevent blurring of the static surroundings, a tripod was used for this photo.

This is useful for creative purposes, allowing you to control the way that a moving subject will appear in your images. Think of a waterfall, for example. If you shoot at 1/500 second, the droplets of water will appear to be frozen in mid-air; that may not provide the flowing effect that you want. Put the camera on a tripod and switch to a shutter speed of 1/4 second and the water will be blurred, producing a convincing portrayal of the motion of flowing water. When you select long shutter speeds, the camera will set a small aperture, so the image will exhibit great depth of field.

On a bright day, it may be impossible to get a good exposure at a very long speed such as 1 second, even at ISO 200; if you try to do so, you will probably get the Exposure Range Warning (a blinking numeral in the viewfinder). To solve that problem, attach a filter with dark glass, such as a polarizer or a Neutral Density filter, to the front of the lens. The darker the glass, the longer the shutter speed you will be able to use on a sunny day.

When you select fast shutter speeds, the camera will set a wider aperture, so the image will exhibit more shallow depth of field. On a dark, overcast day, it may be impossible to get a good exposure at a very fast shutter speed unless you use a high ISO level. If you try to use 1/1000 second with ISO 100, for example, you will probably see the Exposure Range Warning. To solve that problem, switch to a higher ISO level, perhaps ISO 400 or ISO 800. The higher the ISO level you set, the faster the shutter speed you will be able to use.

‹ In order to "freeze" subject motion, a very fast shutter speed of 1/500 second was used for this photo.

The camera's light meter is disengaged when BULB is selected, so you will need to use a handheld meter to calculate exposure. The SteadyShot stabilizer system is also disabled. This option is most useful for night photography to record the moon and stars, a dark cityscape, or fireworks, for example. Many published articles in magazines and online provide hints on the exposure time and aperture that should provide a good exposure in those types of photography.

SCENE MODES

The α500 and the α550 provide six different automatic Scene modes, or programs, that use "intelligent" automation to make suitable exposure settings for common situations and subjects. They are similar to the **AUTO** mode in many aspects, allowing the user to access only a few camera features. However, the Scene modes may set an entirely different shutter speed and/or aperture than **AUTO** mode; they may also modify the color rendition and contrast to produce an effect suitable for a certain type of subject.

As you rotate the mode selector dial to one of the icons for a fully automatic mode, a brief note appears in the LCD monitor about its purpose. Switch to Landscape ▲ mode, for example, and the note will indicate: Shoots the entire range of scenery in sharp focus with vivid colors. TIP: Use wide angle to show vastness of scenery. Unless stated otherwise in the next sections, the built-in flash will pop up automatically and fire in situations where it's needed.

⚡ Flash Off: While this is not a Scene mode per se, it is fully automatic. It's identical to **AUTO** mode, but is intended for shooting in locations where flash is prohibited, so the flash will never pop up or fire.

▣ Portrait: Selects a moderately wide aperture to blur the background; a telephoto lens is recommended for an even more blurred or less distinct background. This mode is also said to "reproduce soft skin tones." Single-shot AF, AF-A autofocus, Wide Area AF, and Single-frame Drive mode are automatically activated.

 Landscape: Sets a moderately small aperture to optimize depth of field and boosts contrast as well as saturation of greens and blues. A landscape is usually too far from the camera for flash to be useful so the flash will not pop up or fire automatically in this mode.

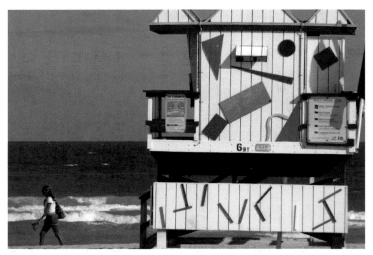

^ The fully automatic Scene modes are intended for quick snapshots, and they usually set a suitable aperture or shutter speed—but not always. In this case, Landscape mode set an aperture of f/11; the depth of field is not quite adequate to keep the person within the range of acceptably sharp focus.

 Macro: The term macro refers to close focusing, or filling the frame with a small subject. This program sets moderate apertures (such as f/5.6 or f/6.3) for shallow depth of field. That should render the subject sharply while blurring the background.

NOTE: Flash should not be used when a subject is less than 3 feet (1 m) from the camera because the lens may block some of the light. If the subject is closer, switch to another mode that will not automatically use flash, such as P or the Flash Off mode.

Sports action: This mode favors fast shutter speeds to "freeze" a moving subject. Continuous AF and Continuous Advance Drive mode are activated automatically. Because an action subject is usually too far from the camera for flash to be useful, the flash will not pop up or fire automatically in this mode.

 Sunset: Very similar to Landscape program, this mode optimizes the photo for richer reds and yellows, providing for a very "warm" effect.

CAUTION: Avoid viewing the sun directly or through the lens because doing so can damage your eyes.

 Night Portrait/Night View: This mode is intended for use with flash to take photos of a nearby person against a moderately dark background, such as a person posing in front of a city scene at night. The camera sets a long shutter speed, as long as two seconds in dark locations. The flash fires at the start of the exposure to illuminate the nearby subject. During the long exposure time, the dark background has time to register on the camera's sensor, so that should be quite bright as well. Use a tripod to prevent blur from camera shake and ask your subject to stay perfectly still to prevent motion blur.

You can also use mode without flash for taking photos of scenes at night. If you want to turn the flash off, press the **Fn** button, scroll to Flash Mode, and scroll up to Flash Off. Because the shutter speed will be very long in low light, use a tripod.

METERING METHODS

It's important to understand the camera's light metering strategies in each of the three options available. To find these options while the camera is in P, A, S, or M mode, press the **Fn** button, scroll to the 🔘 Metering mode item, and press the AF button. You can now scroll to the one you want; then press the AF button to confirm your selection. The following options are available:

🔘 *MULTI SEGMENT METERING*

This system employs a 40-segment honeycomb pattern sensor and artificial intelligence to evaluate brightness in all areas of a scene. The on-board computer also considers subject distance if you are using a Maxxum/Dynax D series lens (with distance data detector chip) or any Sony or Carl Zeiss ZA lens. When the camera is set to autofocus, subject position data provided by the AF system is also considered in the metering computer's analysis.

Because the system compares exposure data with pre-programmed exposure models, it is quite successful at metering subjects with unusual reflectance. For example, in strong backlighting—a friend posing against a setting sun, for example—the system increases exposure automatically to reduce the risk of a dark image. It uses the same strategy for any scene with high reflectance, whether a sunny, snow-covered landscape, or a close-up of a bride in white. The metering system should also compensate for a dark-toned subject, such as a lava field, reducing exposure to render it as black, instead of gray.

While this is a sophisticated metering system that often provides close-to-optimal exposures, its recommendations may not always be ideal. Scenes that are difficult to meter may sometimes require slight adjustments using exposure compensation or bracketing, discussed later in this chapter.

Slight exposure errors may or may not be a problem, depending on whether or not you can correct the errors with image processing software. But even when shooting with RAW, which offers more capacity than JPEG for post-shooting exposure correction without degrading image quality, it is worth taking the time to get a well-exposed image in-camera, using exposure compensation if necessary.

◙ *SPOT METERING*

Spot metering measures only the portion of the scene within the small circular area in the center of the viewfinder. To use it, point the lens so that the central circle etched on the viewing screen covers the target you intend to meter.

One of the most valuable uses of ◙ metering is to measure light values in different parts of a scene for comparison or to determine the exposure gradient in the scene. Another common scenario is a performer under a spotlight against a dark background. Or you might want to take the light meter reading from a small mid-tone subject located in very bright surroundings, such as a cabin in a snowy landscape. These types of scenes often produce less than optimal exposures with other metering patterns.

In the above cases, meter your primary subject, then press and hold the AEL (Autoexposure Lock) button to make sure that the locked-in exposure does not change while you recompose. When you take the shot, the exposure will be optimized for the primary subject.

With experience, this is a useful type of metering. But it can also be tricky because the exposure is significantly affected by the brightness of the selected area. If the target is a mid-tone (a tanned face, for example), the exposure will be accurate. But if you take a spot meter reading of a light-toned area (such as a snowman), underexposure will occur. And if you spot meter a dark area (such as a black cat), the image will be overexposed. Consequently, spot metering is intended primarily for experienced photographers with some expertise in judging tonal values and knowing when exposure compensation must be applied.

⊙ CENTER WEIGHTED METERING

This option measures brightness over most of the scene and averages the data, but it applies extra weight to a large central area. The system does not employ any "intelligent" evaluation, so it's more likely to produce exposure errors than the 40-segment meter.

Photographers who have worked extensively with older film cameras using ⊙ metering may want to use this option. It will often require the use of exposure compensation, with the appropriate amount based on experience or rules of thumb. When applied with expertise, this technique can produce excellent exposures. However, in general, you will get better results with the camera's Multi Segment metering system. You are also better off using ⊡ rather than ⊙ metering when it is advantageous to precisely meter a small area of a scene.

WORKING WITH EXPOSURE

Even when using the very capable Multi Segment metering system in the α500 and the α550, you will still face challenges in getting a proper exposure sometimes. By understanding the tools covered in this section, including exposure compensation, exposure bracketing, auto exposure lock, and the histogram, you'll know when and how to change camera settings to achieve a correct exposure.

⊠ *EXPOSURE COMPENSATION*

After taking a photo in the camera's P, A, or S mode, check it on the LCD monitor. If you think it's too bright or too dark, set some exposure compensation and reshoot the image. Access exposure compensation with the ⊠ button. While pressing and holding that button, rotate the control dial to the right to select a plus (+) value for a brighter image, or to the right for a minus (–) value for a darker image. Watch the scale in the LCD monitor change to reflect your settings and stop when you reach a desired level of compensation.

> **NOTE:** The effects of exposure compensation cannot be seen in the preview display in either of the Live View modes. The ⊠ feature will produce a darker or lighter image, but there is no method for previewing the effect that compensation will provide—you'll just have to shoot and review the image on the LCD screen.

Changes toward the plus side or the minus side are made in 1/3 (0.33) EV increments. EV denotes exposure value, and one full EV change equals one full aperture stop or one full shutter speed step, either of which doubles or halves the light.

⌃ Because most of the image area is lighter than a mid-tone in this scene, exposure compensation of +2/3 was required for an accurate rendition while using ▣ metering. With ◉ metering, a much higher level of plus (+) compensation would have been required.

LUMINANCE LIMIT WARNING

The simplest method for exposure evaluation is to check the photos on the LCD monitor after they have been taken. However, this is not always the most accurate approach. There are also two other methods for analyzing exposure: the histogram and the Luminance limit warning. Both are available in instant review and in the camera's full Playback mode ▶.

When viewing an image in instant review or in Playback mode, press the DISP button until you see a screen with a smaller image area and a lot of shooting data on the right side of the monitor, including four graphs called histograms. These scales indicate the brightness distribution in the image (and we'll cover more about histograms in a moment). Also seen in this display is the Luminance Limit Warning, where any excessively bright or dark areas blink within the image to call attention to possible exposure issues. When bright areas of the displayed image blink, the highlights are "blown out," meaning they are too bright to hold detail. When shadow areas blink, they are "blocked up," or too dark to show detail.

∧ The Luminance Limit Warning can be valuable for checking areas of a photo that are too dark or too light in tone. In this case, the highlight areas are excessively bright because +1 compensation was used. For the subsequent photo, exposure compensation was reset to zero.

Each type of warning (highlight or shadow) flashes alternately; the display uses a different type of pattern for each in order to avoid confusion. This Luminance Limit Warning is not as informative as the histogram display, but it's much easier to interpret. It can certainly help you avoid the most serious exposure problems.

Consider a situation where highlight detail or texture is important, as in a bride's dress or the texture of a flower petal. After taking a shot, check the image with the histogram screen active; watch for a highlight warning in the pertinent area of the image. If the bright part of the image blinks, you'll probably want to re-shoot. Set a -0.3 exposure compensation, take the photo again, and review. If you still get blinking over important bright areas, set a -0.7 exposure compensation factor; take the photo again, and check it for blinking highlights. Keep an eye on shadow warnings at the same time if there is also important detail in shadow areas.

HINT: Although highlight detail is often the most important, be careful to avoid underexposure of important detail in shadow areas. When possible, re-shoot several times, using different levels of exposure compensation for each shot. Also consider using the DRO feature discussed on page 123; that can lighten shadow areas, minimizing the need for complicated, time-consuming corrections with imaging software in a computer.

Sometimes detail or texture in dark areas is particularly important— as in the fur of a black cat that is the primary subject of your photo. In that case, pay attention to the shadow warning. If an important shadow area blinks, it's too dark. Set a bit of plus compensation to increase the exposure, allowing the camera to record more detail, or activate one of the DRO options. The latter may be a better solution because it will lighten dark areas without making the bright areas excessively bright as plus exposure compensation would do.

THE HISTOGRAM

The histogram is a graph indicating brightness distribution from black (on the left side of the graph) to white (on the right side) along the horizontal axis. In instant review or Playback ▶ mode, the α500 and the α550 will display four of these graphs after you press the DISP button.

The top graph, in black and white—called the Luminance histogram—is the most valuable. The other colored graphs relate to individual color channels and are much more difficult to interpret. That's why I'll discuss only the Luminance histogram here.

Take a photo that consists primarily of dark areas (such as a lava field) and the graph will be weighted to the left. Conversely, an image consisting primarily of light tones (such as a snowy landscape) will be heavily weighted to the right. Mid-tone brightness distribution is represented in the central area of the graph. The vertical axis indicates the pixel quantity existing for the different levels of brightness.

If the graph rises as a typical bell-shaped curve, from the bottom left corner of the histogram to a peak in the middle, then descends to the bottom right corner, all the tones of the scene are captured. If the graph starts or ends too far up on either the left or right vertical axis of the histogram, so that the "slope" looks like it is cut off, then the camera is cutting off data from those areas. Some loss of detail is inevitable when the contrast range is beyond the capabilities of the camera—a black vehicle for instance, surrounded by extremely bright sky or sand, for example.

NOTE: You can also see a histogram before taking a photo when the camera is set for Quick AF Live View, by pressing the DISP button twice; the graph will appear in the lower right hand corner of the display. If you set exposure compensation, the histogram will change to reflect the exposure that you'll get at any compensation level. A histogram is not available when the camera is set for MF Check Live View mode, but the preview image is very accurate as to the actual exposure that you'll get when taking a photo. (The display is not as accurate regarding exposure in Quick AF Live View, but the histogram is accurate.)

Keep in mind that there is no single "ideal" histogram. For instance, a photo of groomsmen in black tuxedos against a navy blue wall consists primarily of dark tones. Even if it is perfectly exposed, the histogram will be heavily weighted towards the dark (left) side of the graph. And a winter landscape scene that's perfectly exposed will be weighted heavily toward the bright (right) side of the graph. The key in both cases is to avoid a loss of detail or texture in important areas of the scene.

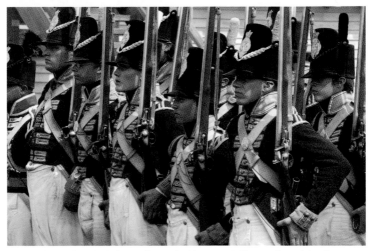

∧ When the Luminance Limit Warning or the histogram indicates a loss of detail or texture in dark areas, set some plus (+) compensation and reshoot the photo.

To render detail in highlight areas, control exposure so the slope on the right reaches the bottom of the graph before it hits the right vertical axis and "drops off" that side. If a scene includes detail elements in shadow areas, manage exposure so that the left side of the slope reaches the bottom of the histogram before it hits the left vertical axis. However, remember that the "real" world is not perfect and you can't always produce a perfect exposure.

Check the histogram after taking a shot and, if necessary, reshoot using a plus or minus exposure compensation setting. Then check the histogram again for the new image. Also check important areas of the image display for blinking; if there's blinking over an important area, it's excessively bright or excessively dark and can't show details. When necessary, set some exposure compensation, and/or activate the DRO feature, and take the photo again.

Both the Luminance Limit Warning and the Luminance histogram provide feedback on exposure and contrast. Once you review the information they provide, you can choose to reshoot the image with different settings. Although some people count on "fixing" exposure and highlight/shadow problems with imaging software, you can't add detail that was never captured in the first place. Whether shooting JPEG or RAW files, always get the best exposure possible in-camera.

Image A (Correct Exposure Histogram): If the graph rises from the bottom left corner of the histogram and then descends towards the bottom right corner without being clipped off on either side, all the tones of the scene are captured. (There may be a few peaks and valleys involved, but the graph still rises from the left and ends very close to the right axis.) Like this example, a well-exposed image will include pure black, pure white, and a good distribution of mid-tones for an effect that should be technically and visually pleasing.

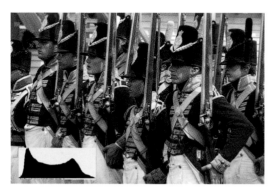

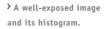
> A well-exposed image and its histogram.

Image B (Underexposure Histogram): A picture that is underexposed will be dark and it will display a histogram where most of the data is in left half of the graph; the slope may be cut off at the left vertical axis, as in this example. This indicates an image with more dark tones than light. The dark sections will fade to black and detail will be lost in the shadow areas; if you later lighten the image in a computer, digital noise will be apparent in those areas. If you see a histogram like this, set some plus exposure compensation and take the photo again; you might also want to set a higher level of DRO (such as Lv 2) to help lighten shadow areas.

> Note this underexposed image and its histogram, and how the histogram is "stacked up" to the left and the graph is clipped off at the left side, indicating a loss of detail in the shadow area.

Image C (Overexposure Histogram): In some images, such as a portrait of a bride in white or a sunlit flower, highlight details are important. In those cases, be sure the slope on the right reaches the bottom of the graph just before it touches the right side. If the slope hits the right axis—as in this example—the image will not hold detail in bright areas of the photo; these details will be blown out as demonstrated by the light areas of this example. If you see a histogram like this, set a minus exposure compensation and take the photo again; that will help to prevent overexposure in the final image.

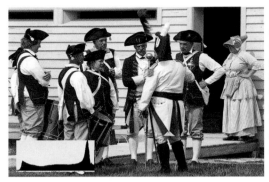

‹ Note this overexposed image and its histogram, and how the peak of the histogram is far over to the right side of the graph. There is also a final spike on this side representing data being clipped.

Image D (Excessive Contrast Histogram): In scenes with extremely high contrast (including very dark shadow areas plus very bright highlight areas) the histogram may show a slope that is cut off at both ends. That indicates that detail will be lost in both highlight and shadow areas. Dark sections of your photo may be completely black while brighter sections may be completely washed out, without visible texture or detail.

‹ This image and its histogram indicate excessive contrast with a loss of texture or detail in both highlight and shadow areas.

Flash Photography

Electronic flash is not just a supplement for insufficient lighting—it can also be a great tool for creative photography. Flash is highly controllable, its color is precise, and the results are repeatable. However, many photographers shy away from using on-camera flash because it can be harsh and unflattering, and taking the flash off the camera used to be a complicated procedure with less than sure results. The sophisticated flash options available with the α500 and the α550—especially with a compatible accessory flash unit—eliminate many of these concerns. Also keep in mind that the LCD monitor provides instantaneous feedback after you take a photo, showing whether the flash exposure was right or not. You can make adjustments if you are not satisfied with your flash exposure and take the photo again. However, it is still helpful to understand the basics of how flash photography works. The following are some of the important standards.

FLASH BASICS

THE INVERSE SQUARE LAW

It's not difficult to understand one of the essential concepts at work with flash photography. As light travels away from its source it also spreads outward, losing intensity. Consequently, the Inverse Square Law, a fundamental principle of light, says that light intensity is reduced by a factor of four as the distance from a source—in this case your flash unit—doubles. Light level drops dramatically according to distance. In fact, if you are 3 feet (0.9 m) from your subject, you need four times as much light to maintain the same level of exposure when you move 6 feet (1.8 m) away from the subject.

GUIDE NUMBERS

Guide numbers (GN) are a comparative reference used to quantify flash output. They are expressed in terms of ISO, in feet and/or meters. The formula to determine guide numbers is GN = distance x aperture. So— according to the Inverse Square Law—a flash unit with a GN of 100 in feet (30.5 m) puts out four times the amount of light as one with a GN of 50 in feet (15.25 m). If your accessory flash has a zoom head, the GN will vary according to the zoom setting.

FLASH SYNCHRONIZATION

The α500 and the α550 are both equipped with a focal plane shutter that consists of two shutter curtains. When you press the shutter release button, the first curtain opens to uncover the camera's sensor and the second curtain covers it. The shutter speed determines the length of time between the first curtain opening and the second curtain closing. To take a photo with flash, the flash must fire when the camera's first shutter curtain is open across the entire frame and before the second curtain begins to close. The fastest speed at which the flash fires while the shutter is fully open is called the maximum flash synchronization speed or sync speed. In fact, in flash photography, we always refer to shutter speed as sync speed.

The maximum sync speed is 1/160 second. When using the built-in flash or a dedicated accessory flash, the camera will not let you set a shutter speed faster than that maximum sync speed. (Some accessory flash units have a high-speed sync feature that allows for using much faster shutter speeds. See page 177.) Naturally, you or the camera can set slower shutter (sync) speeds in flash photography.

THE BUILT-IN FLASH

In order to experiment with the built-in flash, set the camera's mode selector dial to P, A, or S. Since it does not pop up automatically in these modes, you must first manually raise it. Press the $\frac{1}{2}$ button on the left side of the camera (above the AF/MF switch) and the built-in flash will pop up. It will then always fire in these operating modes, regardless of the lighting conditions. You can select any of the options available in

the Flash Modes item in the Function sub-menu (accessed by pressing the camera's **Fn** button). The available flash modes are Fill-flash $\frac{4}{}$, Slow sync $\frac{4}{SLOW}$, Rear sync $\frac{4}{REAR}$, and Wireless $\frac{4}{WL}$. (Each will be discussed in detail in this chapter on page 162.) You can also use flash exposure compensation (see page 169) to increase or decrease flash intensity.

In low light, when the built-in flash is raised, the camera will fire a series of pre-flash bursts as an aid for the autofocus system; this will not occur when Face Detection is on. You can disable this feature if your subjects find it to be distracting by setting the [AF Illuminator item] in the ■ 1 menu from [Auto] (the default) to [Off]. If you are using an accessory flash unit instead, its focus assist illuminator will fire a red beam onto the subject.

FLASH IN AUTO MODES

When the camera's mode selector dial is set to **AUTO** or any of the Scene Selection modes, you will not be able to manually raise the built-in flash. Flash is totally controlled by the camera, as discussed in the Camera and Shooting Operations chapter. The built-in flash will not pop up or fire in any of these modes: Flash off ⑤, Landscape ▲, Sports/Action ⚑, or Sunset ▤. If the flash head is already in the up position when you switch to one of these three modes, it will not fire even in very dark locations. In the other Scene modes and in **AUTO** mode, the flash will pop up and fire in low light by default. It may also fire in situations of strong backlighting: when your subject is lit from behind by the sun, for example. However, the decisions as to when to fire or not fire are made by the processing engine when the camera is at the default Auto Flash setting.

You do have control over the Flash mode in all of the fully automatic modes, except in Flash Off ⚡ mode. Press the **Fn** button and scroll to the **[Flash mode]** item. Press the AF button to reveal the options that are available: Flash Off ⚡, Auto flash ⚡ (the default), and Fill Flash ⚡ (flash fires for every shot).

HINT: When you set a desired Flash mode—such as Fill Flash ⚡—the same Flash mode will be set for all of the fully automatic operating modes. (You cannot set one Flash mode for one Scene mode and a different Flash mode for another Scene mode, for example.) The Flash mode that you set will also remain in effect even when you turn the camera off. If you switch from taking portrait photos with Fill Flash ⚡ to taking landscape photos, for example, you will need to remember to switch to the Flash Off ⚡ mode. (In most cases, a landscape is too far from the camera for flash to be effective anyway.)

⌃ When shooting outdoors, remember to pop the flash head up and to set the flash mode to Fill Flash ⚡.

Good flash photos are definitely possible in the **AUTO** and the Scene modes. By the time you have composed and focused, the flash should be charged and ready to fire, confirmed by a ⚡ symbol in the viewfinder data panel or in the LCD screen in Live View. The camera will set a suitable aperture and shutter speed based on calculations made by the sophisticated multi-segment ◙ light metering system. It will also set a

suitable flash power output, or intensity level. The image should be well exposed as long as your subject is within the flash range (see page below).

NOTE: Although you can set a desired Flash mode in nearly all of the fully automatic operating modes, that is not recommended. These modes are really intended for snap shooting and not for serious photography. Also, they can lead to some confusion as to the effective Flash mode, as mentioned in the earlier Hint. Hence, all further discussions about flash options will refer to photography in the camera's P, A, S, or M exposure modes.

Regardless of the operating mode that you use, the flash must recycle or recharge after firing. You cannot take the next shot while the ⚡ symbol is blinking; that signal indicates that the flash unit is not yet ready to fire. When the blinking stops, you can take the next flash photo.

FLASH RANGE

The built-in unit is not particularly powerful, but it has adequate range for most snapshots and people pictures. The effective range varies with the aperture that's used: it's greater at larger apertures (f/4 for example) than at smaller ones (f/11). Effective range also varies depending on the ISO selected: it's greater at higher ISO settings. The following chart provides effective flash range at f/4, a common maximum aperture at the short end of many variable aperture zoom lenses, and at f/5.6, a maximum aperture that's common with these lenses at the medium to longer focal lengths.

The chart on the next page provides the effective flash range only up to ISO 1600. You can use flash at higher ISO levels, but I don't recommend doing so. (The higher ISO levels are intended for use in low light when a tripod cannot be used.) Photocopy this chart and carry it in your camera bag along with the wallet card found in the back of this book. And don't ignore the minimum range. Moving very close for a frame-filling close-up—especially when using a high ISO setting—can produce excessively bright flash photos.

> The built-in flash is quite small so its effective range is not great unless you are using a very high ISO level. Still even at ISO 200 to 400, the range is adequate as long as you use a wide aperture or are quite close to the subject.

ISO SETTING	F/4	F/5.6
200	1 – 4.3m; 3.3 - 14 ft.	1 – 3m; 3.3 - 9.8 ft.
400	1 – 6m; 3.3 - 20 ft.	1 – 4.3m; 3.3 - 14 ft.
800	1.4 – 8.6m; 4.6 - 28 ft.	1 – 6m; 3.3 - 20 ft.
1600	2 – 12m; 6.6-39 ft.	1.4 – 8.6m; 4.6 - 28 ft.

Although the flash range is impressive at ISO 1600 at these wide apertures, remember that image quality will be lower at very high ISO levels due to increased digital noise. Consequently, you might consider buying one of the powerful accessory Sony HVL-AM series flash units (with at least double the effective range). This will allow you to shoot at lower ISO settings for superior image quality.

The α500 and the α550 support full-featured flash photography with the compatible accessory flash units. These include the Sony HVL-F56AM, HVL-F36AM, HVL-F42AM, and the new HVL-F20AM models, as well as the (discontinued) Maxxum/Dynax D and HS-D series flash units. With these models, you can take advantage of wireless off-camera TTL flash, high-speed sync flash, rear-curtain flash synchronization, bounce flash, and wireless off-camera flash.

The cameras are also compatible with the HVL-MT24AM/HVL-RLAM Macro flash units designed specifically for extremely close focusing when using a Macro lens. While some older Maxxum/Dynax flash units—not bearing the HS-D or D series designation—can also be used with the α500 and the α550, they require the optional Sony Flash Shoe Adapter FA-SA1AM, and they must also be used in Manual flash mode—a somewhat complicated and inconvenient process. (That adapter is very difficult to find but you should be able to find one online. Of course, Manual flash mode is not very convenient and you may prefer to spend the money on a new HVL flash unit instead of buying the adapter.)

The fully dedicated, or fully compatible, flash units also allow you to utilize sophisticated ADI (Advanced Distance Integration) flash metering. However, that also requires the use of D-series Maxxum/ Dynax lenses, any Sony lenses, or any of the Carl Zeiss ZA series for the Alpha cameras. All of these lenses include the distance data detector chip. ADI flash uses distance information from the appropriate lenses to control the flash output and is less affected by very bright or very dark subjects than is Pre-flash TTL metering, which does not use distance information (see page 162). (The flash metering system cannot employ distance data when non D-series lenses are used.)

At the time this guide was prepared, Sony marketed the following flash units:

HVL-F56AM: This is a large model with high power output. Its Guide Number (GN) is 185/56 (feet/meters) at ISO 100 using the 85mm zoom head setting. This model features an illuminated LCD data panel, power zoom flash head to match focal lengths from 24mm to 85mm, wide-angle diffusion panel (for use with lenses as short as 17mm), focus-assist illuminator, plus several functions for additional creative options. In addition to conventional upward tilt capability, this unit allows for tilting the head 10° downward for close-up photography, and can be rotated to the side for bouncing flash from a wall.

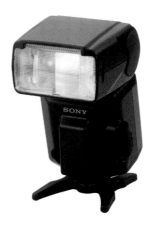

HVL-F42AM: This slightly smaller unit is less powerful, with a GN of 42/13 (feet/meters) at ISO 100 when the zoom head is at the 105mm setting. It includes nearly all of the features of the larger model, and offers greater versatility with 24mm to 105mm zoom head settings, but omits the downward tilt capability. Thanks to improved circuitry, this model can recycle (recharge) 38% more quickly than the less powerful HVL-F36AM model, discussed below.

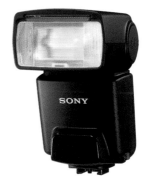

Flash HVL-F20AM: This latest model from Sony is unusually small and lightweight; it can be left on the camera at all times, and folded down when not in use. It's a very basic unit but does allow for tilting the head up for bouncing light from a ceiling. The GN of 66/20 (feet/meters) at ISO 100 indicates that its' more powerful than the built-in flash whose GN is 39/12 (feet/meters).

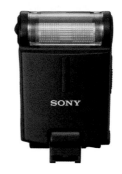

Flash HVL-F36AM: A dis-continued model, this one may still be available from some dealers. It's more compact and provides lower power. The GN is 118/36 (feet/meters) at ISO 100 using the 85mm zoom head setting. It lacks an LCD data panel, but has a power zoom flash head to match focal lengths from 24mm to 85mm, a wide-angle diffusion panel (for use with lenses as short as 17mm), and a focus-assist illuminator. The head only tilts upward for bouncing flash off a ceiling.

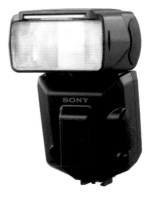

MACRO FLASH UNITS

Sony offers two flash units designed specifically for macro photography:

Macro Twin Flash Kit HVL-MT24AM: This is a large piece of equipment consisting of a controller unit that mounts in the camera's hot shoe and two distinct flash tubes on adjustable arms, mounted on a ring that attaches to the front of a macro lens. The two primary components are connected with a cable that's included in the kit. Either or both flash tubes can be used at any time and their position can be modified by rotating the

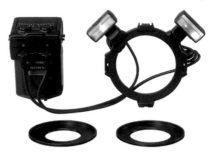

attaching ring. Each flash head has a GN of 40/12 (feet/meters). The Twin Flash Kit comes with 49mm and 55mm adaptor rings, wide-angle diffusion panels, and a storage pouch.

Macro Ring Light HVL-RLAM: This is a professional-caliber unit designed for extreme close-up photography with a macro lens. It does not provide as many automatic features and must be used with the flash shoe adapter FA-SA1M; this is necessary for mounting the controller unit in the hot shoe of any of the Sony Alpha camera or the discontinued Maxxum/Dynax 5D and 7D cameras. The Macro Ring Light is quite powerful with a GN of

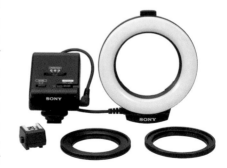

79/24 (feet/meters) at ISO 100. Its circular head includes four flash tubes that can be individually illuminated. Use all four for even lighting, or select specific tubes for more directional lighting. The kit includes 49mm and 55mm adapter rings for attaching the ring light to the front of a macro lens.

FLASH METERING OPTIONS

The α500 and the α550 allow you to select from two options for flash metering control in the ◘ 1 menu. The following information clarifies some of the concepts relating to those options.

ADI FLASH (ADVANCED DISTANCE INTEGRATION)

This is the most sophisticated TTL (through the lens) metering option. It's available only when using Sony, Carl Zeiss ZA, or Maxxum/Dynax D-series lenses with either the built-in flash or a fully compatible accessory flash unit. The camera's microcomputer uses focus distance data provided by the lens, plus aperture and ISO information, to set the flash exposure. This increases the odds of a good exposure because it is less influenced by high or low subject reflectance, and therefore more likely to produce a good exposure with white or black subjects that might otherwise lead to under or overexposure, respectively. I recommend this option for those who use a compatible lens and the built-in flash or a fully dedicated external flash unit.

^ Sony's ADI flash metering often provides accurate flash exposures, even with very dark or very light-toned subjects.

NOTE: If the AF system is unable to find focus, or if you're using manual focus, the camera will automatically switch to the other option: Pre-flash TTL control. The same will occur when using an accessory flash for wireless off-camera flash photography or a Maxxum/Dynax lens without the D-series designation. Finally, note that Sony recommends selecting the Pre-flash TTL mode when using filters that reduce light transmission (such as a polarizer) or when utilizing an accessory flash unit's wide-angle adapter (diffuser).

PRE-FLASH

This is the standard TTL flash metering mode for use with non D-series lenses or in the circumstances noted above. With this technology, a brief burst of flash is fired before an exposure is made. The camera's microcomputer analyzes the scene based on the pre-flash to determine the appropriate light output for exposure. Most of your flash exposures will be fine, unless the subject is unusually light or dark, or is located against a very bright or dark-toned background.

HINT: White or other light-toned subjects and back lighting or a bright sky can lead to underexposure—the subject will be too dark. Conversely, black or other dark-toned subjects and backgrounds can lead to over exposure— the subject will be too bright. Check your images on the LCD monitor. If an image would benefit from different flash intensity, set a plus or minus flash exposure compensation and take the photo again (see page 169).

FLASH PHOTOGRAPHY AND CAMERA EXPOSURE MODES

Whether you're using the built-in flash or an accessory unit, you can shoot with any of the camera's operating modes. Any of the three metering patterns can be used, but you'll usually get the best flash exposures when using the multi-segment ◙ light meter. Flash photography with **AUTO** mode and the Scene Selection modes was already covered earlier (on page 136), so I will not repeat that information.

FLASH MODES

When using the camera in the P, A, S, or M exposure mode, you can select any of three Flash modes in the Function sub-menu. Scroll to this item, press the AF button, scroll to the desired option, and press the AF

button again to confirm your decision. Any of the following can be used with the built-in flash or a dedicated accessory flash unit.

⚡ Fill-Flash: The default flash mode, this is suitable for use in bright conditions, such as on a sunny day. The camera's metering system will automatically reduce flash output slightly so the flash provides only "fill" light: to lighten or fill-in shadows. But this mode is also useful when shooting in dark locations; flash will provide the necessary illumination in such conditions.

︿ When the Fill Flash mode is set the camera will always fire flash, even in bright light, which is useful for brightening shadow areas. Naturally, the built-in flash must be in the up position or the accessory flash unit must be On.

⚡slow Slow: When this mode is set, the camera will set a slow (long) sync speed when you're using the P or the A exposure mode. (When you use the S or M mode for flash photography this flash mode has no effect since you are required to set the shutter speed yourself.)

⚡ SLOW Slow Sync: Slow Sync can be useful when taking photos of a nearby subject lit by flash against a distant, not excessively dark, background. For example, use this setting to photograph a person against a nighttime cityscape. The long exposure time will record the ambient light in the scene without affecting the flash exposure. Use a tripod to avoid blur from camera shake and have your subject remain still during the entire exposure.

⚡ REAR Rear: This option refers to rear curtain sync—a feature that causes flash to fire at the end of an exposure, not at the start of an exposure as in conventional flash photography. When used for shooting moving subjects at long shutter speeds (preferably 1/15 second and longer), this feature produces the effect of motion streaks that follow the subject instead of preceding it. Some photographers also use rear sync for long exposures of static objects or people, moving the camera to produce interesting flash blur effects.

⚡ WL Wireless: Select this flash mode only if you own a fully dedicated accessory flash unit and want to use it off-camera without an optional cable to connect the flash unit to the camera's hot shoe. (This technique is discussed in detail on page 174.) Wireless (also called 'remote') flash will work with one or more of the following units: the Sony HVL-AM series and the (discontinued) Maxxum/Dynax HS(D) models.

FLASH WITH P, A, S, AND M EXPOSURE MODES

Before moving on to some advanced flash techniques, let's consider basic flash photography—with the built-in flash or a dedicated accessory unit—in the camera's four primary exposure modes.

Program (P): Flash photography in P mode can be quite simple. The camera's metering system controls the shutter speed and aperture used for each shot. (With flash photography, you cannot use the Program shift feature.) The camera also controls the flash output. However, you can set any desired ISO, flash control option, flash mode, and flash exposure compensation (discussed on page 169). When you do so, the camera will not automatically revert to the factory-set defaults when it is turned off or when it goes into Sleep mode.

‹ Flash is certainly useful in low light but it's also valuable outdoors in backlighting making it easy to get a pleasing exposure for the subject, without affecting background brightness.

Aperture Priority (A): When using flash in this operating mode, you select an aperture (f/stop) by rotating the camera's control dial. The aperture used will determine the flash range. The maximum flash-to-subject distance decreases with each smaller aperture setting. The chart on page 156 shows the range of the built-in flash at two apertures; at higher f/numbers, the effective range decreases significantly. If you're using an accessory flash unit with a data panel, it will provide information about the flash range at any aperture. The camera will set a shutter speed from 1/60 second to 1/160 second.

NOTE: When using flash in A mode, the camera will provide a warning if you set an aperture that is likely to produce overexposure: the shutter speed numeral in the viewfinder will blink. If that happens, set a smaller aperture (such as f/11 instead of f/5.6, for example), or switch to a lower ISO level, until the blinking stops.

The camera does not provide any advance warning in situations where underexposure may occur. If your subject is too far from the flash or a very small aperture is being used, your flash photos may be too dark. (This is less of a problem when using a high-powered accessory flash unit with a great effective flash range.) After taking a photo, check it on the LCD monitor; if it is underexposed, set a larger aperture (such as f/5.6 instead of f/16), a higher ISO level, or move closer to the subject. Then, take the shot again.

^ Especially with the built-in flash, it's important to set a high ISO level and a wide aperture when you cannot move close to the subject in low-light conditions. For this photo, ISO 800 and f/5.6 were used to minimize the risk of underexposure.

Shutter Priority (S): When using flash in S mode, you select a shutter speed and the camera will set the aperture. You can set shutter (sync) speeds as long as 30 seconds and as short as 1/160 second. The shutter speed cannot exceed that maximum flash sync speed so the camera will not allow you to set a faster shutter speed (except when using the special High-speed Sync feature discussed on page 177). When using one of the compatible accessory flash units with a data panel, you'll find useful information about flash range before taking a photo.

Changing the shutter speed will not affect the exposure in conventional flash photography. However, it does allow you to control how ambient light will be rendered. This is especially useful when you

have a flash-lit subject in front of a somewhat dark background that you want to be rendered naturally. An example would be your subject in front of a city scene at dusk or a beautiful sunset. If you don't intentionally use a long shutter speed, the picture will probably have a flash-lit subject against a very dark or black background.

Make sure you use a tripod when shooting at long shutter speeds to prevent blur due to camera shake. The S mode is also useful when you want to render ambient light motion blurs and a sharp, flash-exposed subject. You should set the camera for Rear sync (see page 174) and use a long shutter speed to capture the ambient exposure of the moving subject. The camera will produce an image with light trails that follow a sharp subject (illuminated by the brief burst of light).

NOTE: When using flash in S mode, the camera will provide a warning if you set a shutter (sync) speed that is likely to produce overexposure: the f/number in the viewfinder will blink. If that happens, set a slower speed (such as 1/30 sec. instead of 1/160 sec., for example), or switch to a lower ISO level, until the blinking stops. The camera does not provide any advance warning in situations where underexposure may occur.

Manual (M): In the M operating mode when using flash, you must set a desired aperture as well as shutter (sync) speed between 30 seconds and 1/160 second. Although the camera's M mode is a manual control option, full flash automation is still provided by the light metering system.

Using the camera's Manual mode for flash photography provides more creative control. The photographer can adjust the relationship between the flash and ambient light exposure. In Manual mode, the exposure scale in the viewfinder operates, but it only provides a reading for the ambient light in the scene.

If you want the lighting on the subject and the background to be balanced, set the shutter (sync) speed and aperture for correct ambient light exposure. If you wish to make an image with a brighter or darker background, you can adjust the shutter speed or aperture. A longer shutter speed provides a brighter background. To set off your subject against a darkened background, use a faster shutter speed or a smaller aperture. (If you close down the aperture, make sure the subject distance is still within the flash range.) Watch the scale in the viewfinder and

^ Flash photography in the camera's Manual mode is not as simple and quick as in other modes, but it provides great control over the lighting effect.

stop making adjustments when the marker indicates a desired level of difference between subject brightness and background brightness. If the marker on the scale indicates -2 for example, the background will be about 2 EVs, or stops, darker than the subject illuminated by the flash.

The scale provides data in a +2 to -2 EV range. In many typical conditions, the brightness of the background is not substantially higher or lower than the subject brightness, so the +2 to -2 scale should be adequate. If the background brightness is substantially different than subject brightness—common in very dark locations or with extremely bright backlighting—an arrow at the end of the scale blinks.

Take notice of the flash range, especially when using small apertures; the camera provides no advance warning that the settings in use will underexpose the shot. Check your photo on the LCD screen. If it's dark, set a larger aperture or a higher ISO. When using one of the compatible accessory flash units with a data panel, you'll find useful information about flash range before taking a photo. It varies depending on the ISO, the aperture that you've selected, and the position of the flash unit's zoom head.

Regardless of the flash options or shooting techniques used, you may well find that some exposures exhibit more or less flash than you want. After taking any flash photo, review the image on the camera's LCD screen. If you would prefer a stronger flash or gentler flash effect, simply set flash exposure compensation before taking the shot again. This camera feature will modify only the flash output (intensity); it will not change the aperture or shutter (sync) speed.

FLASH EXPOSURE COMPENSATION

Particularly in outdoor photography, you may find that you prefer less flash intensity than the system produces at its default. If so, scroll to the [Flash Compens] item in the Function sub-menu. Press the AF button and a scale will appear on the LCD screen with a pointer at zero, indicating that no flash intensity modification has been set. Scroll to the right (the plus side) to increase flash output or to the left (minus side) to decrease flash output for the subsequent photos that you will take.

This camera feature is effective with the built-in flash and with an on-camera accessory flash unit. (If you also set flash exposure compensation with an accessory unit, that will take precedence over the setting made in the camera.) After you set flash exposure compensation, a ⚡️ symbol will appear in the viewfinder and in the LCD screen as a reminder. Remember to reset this feature to zero when you no longer want to modify flash intensity.

Try setting a -1 flash exposure compensation factor when you want a very subtle flash effect in outdoor photography. Reshoot and examine the new photo. If it's not quite right, simply access the Flash compensation function and set a slightly different level. Take the photo again. With a bit of experience, you'll become quite adept at judging the amount of minus flash compensation that you might want to use in most situations.

Sometimes, a flash photo will appear underexposed: the subject will be too dark. This can occur when a subject is white (or another very light tone) or is posing against an extremely bright background. When the subject is too dark in a flash photo, try a +1 flash exposure setting and take the shot again. You may need to take several photos, at various compensation levels, to get one image that's technically perfect. Again,

^ Assuming that the subject is well within the effective range of the flash unit, a -2/3 or -1 flash exposure setting can be useful outdoors for a more subtle flash effect.

with experience, you'll learn to judge the amount of flash compensation that's likely to be suitable.

The ideal amount of flash exposure compensation will vary based on the subject, lighting conditions, and your personal preferences. Note that flash compensation affects only the amount of light output by the built-in or accessory flash. The aperture and shutter speed settings do not change when flash exposure is used, so ambient light exposure is not affected. Only the subject—and not the background—will be lighter or darker in a subsequent flash photo.

NOTE: The flash exposure compensation feature will have no value if the subject is too close to the camera or too far from the camera. When shooting extreme close-ups, for example, flash intensity may be excessive even after you set a -2 flash exposure compensation level. (In that case, set a lower ISO level, a smaller aperture (such as f/16 instead of f/5.6) and/or move further from the subject. With a very distant subject, the light from flash may simply not reach adequately far; setting a +2 compensation will have no effect in that case. (In this situation, try setting a higher ISO level and/or moving closer to the subject and/or switching to a high-powered accessory flash unit.)

USING FLASH WITH EXPOSURE COMPENSATION

In some situations, you may want to use the camera's conventional exposure compensation control during flash photography. This will modify both the flash exposure and the ambient light exposure. While depressing the ⊠ button, rotate the control dial and set the desired exposure compensation level. (This control is not active while shooting in the camera's M mode, so experiment while shooting in P, A, or S mode.)

NOTE: The conventional exposure compensation feature is most useful in flash photography when an entire image is too dark or too light. After you set exposure compensation with the ⊠ button, the metering system will adjust both the ambient light exposure compensation and the flash exposure compensation. If you set a +1 exposure compensation level using the ⊠ button, the nearby subject (illuminated by flash) as well as the background (illuminated by ambient light) will be brighter in the next photo. Conversely, if you set a -1 exposure compensation level, both will be darker in the subsequent photo.

You can also use both types of compensation simultaneously—for modifying flash intensity ⊞⊠ by a certain level of compensation and for modifying the ambient light exposure with a certain level of exposure compensation ⊠. For instance, you might set exposure compensation to -1 and flash exposure compensation to +1. That combination would produce a photo with a darker background and a brighter nearby subject. Or, set exposure compensation to +1 and flash exposure to -1 for a photo with a brighter background but a darker nearby subject.

You can achieve a wide variety of effects with this advanced technique, but it does call for a lot of experimentation. Try different levels for each control and check the resulting images on the camera's LCD screen. With some experience, you'll soon become adept at estimating what settings will produce the most accurate, or creatively pleasing, exposure for the subject and for the background in flash photography.

OTHER FLASH OPTIONS

In addition to features already discussed in detail, the α500 and the α550 provide other options for flash photography. Red-eye reduction is available only with the built-in flash. Rear curtain flash sync and slow sync are available with both the built-in flash and dedicated accessory flash units. Two other options, wireless off-camera remote flash control and high speed sync, can also be used, but that's possible only with certain accessory flash units.

RED-EYE REDUCTION

Available in the ✿ 1 menu, this feature is recommended for use when photographing people or animals in dark locations with the built-in flash. When set to On, the flash unit fires several bright bursts intended to reduce the size of the subject's pupils and minimize the red-eye effect. (With pets this is often a blue or green effect, but the cause is the same.) After the pre-flashes, the actual flash burst is fired. This feature is occasionally successful in reducing red-eye, but people tend to be annoyed by the bright pre-flashes.

You can also activate a series of pre-flash bursts—even if Red-eye reduction flash is not set in the menu—by pressing the camera's AF button while the built-in flash is up. The multiple bursts can help minimize red-eye; you can activate this feature several times if desired. The pre-flash bursts will also provide a brighter target for the Autofocus system. The latter can be useful if the AF system was unable to set focus using the automatically activated pre-flash bursts.

HINT: I do not recommend activating Red-eye reduction flash unless you find that the built-in flash produces terrible red-eye in certain circumstances. There are two drawbacks: the bright pre-flashes may cause your subjects to blink or appear unnatural; and there's quite a long delay from the instant that you press the shutter release until the actual exposure is made (during that time, your subjects' expression or position may change).

Effective Ways to Reduce Red-Eye:

o Ask the subject not to look directly at the lens

o Turn up the room lights to cause the iris in the eye to close down, reducing the risk of red-eye

o Use an accessory flash unit that sits higher above the camera, and hence, further from the lens; the greater flash-to-lens axis distance minimizes red-eye

o Use an accessory flash unit, and bounce the light from a ceiling or wall if your flash unit includes a tilt or swivel head feature

o Use off-camera flash instead of on-camera flash to maximize the distance between the light source and the lens axis; hold the remote flash unit above and to one side of your subject

o Use the red-eye correction tool if available with your image-editing software program

⚡ SLOW SYNC FLASH

You can set a slow shutter speed (sync speed) such as 1/15 second or 1/4 second—or even 30 seconds in very dark locations—while using the camera's Shutter Priority or Manual modes for flash photography. If you want to take flash photos during a long exposure when using the camera's Aperture Priority mode, set the Slow Sync mode in the Function sub-menu. After you do so, the camera will set a longer than usual shutter speed (sync speed) when the built-in flash or an accessory flash unit is active. (The actual sync speed will depend on scene brightness and the ISO setting.)

This function can be useful when taking photos of a nearby subject lit by flash against a distant, not excessively dark, background. For example, use this setting to photograph a person with a nighttime cityscape in the background. The long exposure time will record the ambient light in the scene without affecting the flash exposure. (You can also achieve a similar effect with full camera automation using the Night View Scene Selection mode.) Mount the α500 or α550 on a sturdy tripod to avoid blurring from camera shake. Change the aperture from large (such as f/5.6) to small (such as f/16); watch the shutter speed data in the viewfinder changing as you set smaller and smaller apertures. (If the f/number blinks and ask your subject to remain still during the entire exposure which can last for several seconds.

⚡ REAR SYNC FLASH

One of the options available in the Flash Mode item of the Function sub-menu, ⚡ causes flash to fire at the end of an exposure when the shutter mechanism's second, or rear, curtain opens. This feature is also called rear curtain or second curtain sync because flash fires just before the second shutter curtain closes. In conventional flash photography, flash fires at the start of an exposure just after the first shutter curtain opens to allow light to reach the sensor.

When used for shooting moving subjects at long shutter (sync) speeds (preferably 1/15 second or longer), Rear Sync produces the effect of motion streaks that follow the subject instead of preceding it. Some photographers also use Rear Sync for long exposures of static objects or people, moving the camera during the exposure time to produce interesting flash blur effects.

MOTION BLUR—HOW IT WORKS

In order to create motion trails that follow an object, the flash must fire at the end of the exposure, using the Rear sync option. If the flash is fired using the standard flash mode (front curtain sync), the moving object is "frozen" at the beginning of its travel and then the motion trail is recorded. This captures the action but the motion trail appears to be in front of the moving object. However, if the flash fires just before the shutter closes (rear curtain sync), the camera will record the ambient light motion blur and then freeze the subject. Thus, the photo will appear natural, with the motion trail following the object. This technique can produce dramatic action shots, so take the time to experiment with your camera and flash until getting the effects you want becomes second nature.

OFF-CAMERA FLASH

On-camera flash is certainly convenient and the accessory flash unit works in the same manner as the built-in flash. That makes it particularly easy to use after you are fully familiar with the camera's flash modes and various options. For more serious photography, however, the α500 and the α550 can be used with an accessory flash unit that's off camera, perhaps held above and to the side of the subject for a more professional

lighting effect. That's possible with any dedicated flash unit when using an optional FA-CC1AM Off-Camera Cable to connect the flash unit to the camera's hot shoe. This accessory ensures that full TTL metering and automation are available with one remote flash unit.

> **NOTE:** The FA-CC1AM Off-Camera Cable works perfectly with the pro-caliber HVL-F36AM flash unit. If you want to use this cable with other HVLF flash units, you will require the optional FA-CS1AM Off-Camera Shoe for Flash adapter accessory.

Frankly, there is no need to buy the cable. Both the α500 and the α550 support off-camera flash without the need for any connection to the camera, using wireless remote TTL flash. This feature is available when using one or more of the following units: the Sony HVL-AM series units or the Maxxum/Dynax HS(D)-series. Start by setting the Wireless d option in the [Flash mode] item of the Function sub-menu. Then, proceed as follows; start by experimenting with the camera in the P, A, or S mode.

Mount the accessory flash in the camera's hot shoe and turn both on. After setting the d option, remove the accessory flash unit from the camera. Then, pop up the built-in flash head. During that test, and when taking photos, the off-camera flash is triggered by a burst of light from the built-in flash. Metering control is TTL, making it quite easy to get good exposures without any calculations.

WIRELESS/REMOTE FLASH TECHNIQUES

When the accessory flash unit is charged and ready, its red AF illuminator lamp blinks, indicating that you can take the photo. The built-in flash will fire a low intensity burst—just enough to trigger the remote flash but not enough to light the subject. High-speed sync (see page 177) can be used in wireless flash. Just remember that this feature reduces the effective flash range very significantly, especially at very fast shutter speeds. (The flash range display in the LCD screen—common with the high-end flash units—does not work in Wireless flash photography.)

^ Wireless off-camera TTL flash is not complicated and can provide more pleasing effects than direct on-camera flash.

Make sure that the remote flash unit maintains the line of sight with the on-camera flash. To be certain, take a test shot. If your flash photos are too dark or too light, set a plus or minus exposure compensation with the camera's ⊠ feature or use only the 🔆⊠ feature (as discussed earlier on page 169). If you prefer, you can also use the accessory flash unit's own flash exposure 🔆⊠ compensation control to increase (plus) or decrease (minus) flash intensity. Remember to reset both controls to zero after they are no longer required.

Flash Range: Wireless flash photography works best indoors, in a location that is not excessively bright. It's important to position the remote flash unit so it's not too close to or too far from the subject. The distance between the remote flash and your subject should be at least one meter (or 3.3 feet). The maximum distance between flash and subject will vary depending on the power of your flash unit and the ISO level that you set on the camera. It will also vary depending on the aperture you have set on the camera. When shooting at f/5.6, for example with an HVL-56AM flash unit, using ISO 200 and a sync speed of 1/160 second or 1/125 second, place the flash unit no further than 5 meters (16.4 feet) from the subject. (Additional information on Wireless remote flash range is available with the data sheets packaged with the various Sony flash units.)

NOTE: To confirm that the built-in flash will trigger the off-camera flash unit, press the AEL button. If the Wireless connection is working, both flash tubes will fire a short burst. Unlike the high-end Sony cameras, the α500 and the α550 cannot control more than one off-camera flash unit in Wireless flash photography. After you finish shooting in Wireless mode, be sure to change from Wireless ⚡ flash mode to another flash mode in the Function submenu. If you forget to do so, your exposures (when using the built-in flash) may be incorrect.

HIGH-SPEED SYNC (HSS)

This feature is available only with Sony HVL-AM flash units that support HSS and with the (discontinued) Maxxum/Dynax HS(D)-series flash units. When activated, High-speed sync (HSS) mode allows the flash to sync at shutter speeds faster than the normal maximum sync speed (1/160 second). The HSS function is set on the flash unit and allows you to take flash photos at shutter speeds as fast as 1/4000 second. Instead of firing a single burst of light when the shutter is open, HSS mode fires a series of short, lower intensity bursts as the shutter curtain travels across the image plane.

‹ Use one of the optional flash units that supports HSS and you can take flash photos with fast shutter speeds. This can be useful in outdoor photography when you are close to the subject and want to use a wide aperture for shallow depth of field.

Fast shutter speeds are associated with stopping subject motion, so people may mistakenly think HSS is for photographing moving objects with flash. It is not. This setting is useful when you want to use flash for a subject in bright sunlight, especially with a very wide aperture, such as f/2.8. When using flash at the conventional 1/160 second sync speed, it is likely the image would be overexposed. Using a fast shutter speed controls only the bright ambient light exposure and prevents it from overpowering the flash exposure. By making the photo with a faster sync speed, such as 1/500 second, you can correctly expose for the ambient light and flash.

To utilize HSS, attach one of the specified flash units to the camera's hot shoe and set it to the HSS mode. Note that HSS cannot be used when Rear sync or one of the self-timer options is set on the camera. HSS works in the camera's A, S, and M modes, when you need to use a shutter speed faster than the normal 1/160 second sync speed.

Experiment with HSS on a bright sunny day and set the camera's ISO to 400. Start by using the camera's Shutter priority (S) mode and try setting a shutter speed of 1/250 second or 1/500 second while the accessory flash unit is on. Or switch to the Aperture priority (A) mode, set a high ISO on the camera, and select a wide aperture like f/2.8 or f/4; that should cause the metering system to set a fast shutter speed.

If the flash unit includes a data panel, check the information as to flash range; that will change as you or the camera sets different shutter speeds. If the range is not suitable for the camera-to-subject distance, select a different shutter speed and check the data panel again. Setting a higher ISO level in the camera can increase the effective flash range at any shutter speed.

Although you can select shutter speeds as fast as 1/4000 second when using HSS flash, you'll rarely need to use anything faster than about 1/500 second. The flash unit's guide number is dramatically reduced when you use HSS as you select faster shutter speeds in this unconventional flash mode. The flash range also becomes quite short when you select a small aperture (such as f/11 instead of f/4). Unless you're using a very high ISO setting for extreme close-ups in very bright sunshine, a sync speed of 1/250 second to 1/500 second will often be perfect when shooting at wide apertures.

BOUNCE FLASH

Direct flash can often be harsh and unflattering, causing heavy shadows or a "deer in the headlights" appearance in your subject. Using off-camera flash—slightly above and to the side of the subject—can be useful for people pictures. You could also try bouncing the light from flash off a wall or ceiling to diffuse the light for a softer effect. You can utilize this technique whether the accessory flash unit is on- or off-camera. Sometimes the effect will be too soft with very flat contrast; if that is often a problem, try setting a higher in-camera Contrast level; this feature is available by scrolling to the right from any Creative Style mode, accessed in the Function sub-menu. You can also modify the contrast later, with image-editing software.

Most compatible accessory flash units feature heads that are designed to swivel and tilt, although some only allow for tilting upward. Either type can be useful for allowing an on-camera flash to be adjusted so it is not aimed directly at the subject. You can point the flash toward the ceiling at a point about halfway between the flash and the subject. If the head also swivels, you can point it toward a wall beside the subject. Either technique can produce softer lighting. However, the ceiling and walls must be white or light gray or they may cause an undesirable color cast.

NOTE: When you bounce flash, the LCD data panel will not show the effective flash range, nor is such data published in owner's manuals—it depends on the distance from the camera to the bounce surface plus the distance to the subject. As a rough estimate, assume that flash range is about half of what it would be with direct flash photography. It can be greater than that if the bounce surface and subject are quite close, or less if the subject and/or the surface is very far from the camera or each other. After taking a photo, check the LCD screen. If it's too dark, use a wider aperture (such as f/4 instead of f/11) and/or select a higher ISO level to increase the effective flash range.

Working with Images

Taking great pictures with your α500 or α550 is only one component of the digital photography experience. You may also want to download images to a computer, convert RAW files to a familiar format, file and store your photos for easy access and viewing, enhance them using image processing programs, and make or order prints.

IMAGE DATA

A wealth of information is recorded when you shoot a digital picture. This data is stored in the Exchangeable Image File Format or EXIF, often referred to as the generic term, "metadata."

 This EXIF data embedded with the image file includes: date and time of recording, aperture, shutter speed, ISO, exposure mode, metering mode, lens focal length, white balance setting, color mode, exposure or flash compensation, and settings for color saturation, contrast, or sharpness. Some of this information will be used by the printer in direct printing from photos on your memory card.

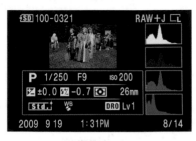

< While reviewing images in Playback mode, it's worth checking the EXIF data as well as the histograms.

You can examine some of the EXIF data on the camera's LCD monitor in instant review or in Playback ▶ mode, when the histogram display is active; to view that screen, press the DISP button twice. You can also review all of the data using the Sony software or other brands of imaging programs. (Not all programs list every item of EXIF data, however.) It's worth occasionally checking all of the data as a reminder of the camera settings that you used. Compare pictures and data to learn more about exposure, depth of field, the depiction of motion, flash exposure, and so on.

HINT: In order to find full EXIF shooting data, right click on an image that's displayed in the Sony browser program's screen. Select the Image Properties option from the drop-down menu that appears. Some other brands of browser and image-editing programs allow you to access EXIF data in the same manner. Others programs require you to find the Properties or File Info command.

> The Sony software can provide a list of the most important EXIF data.

Image Properties		☒
Item	**Value**	
File name	_DSC0329.ARW	
File type	ARW 2.1 (compressed) format	
Date taken	9/13/2009 10:20 AM	
Created	9/13/2009 10:20 AM	
Image width	4592	
Image height	3056	
Orientation	Standard	
Manufacturer name	SONY	
Model name	DSLR-A550	
Lens name	DT 16-105mm F3.5-5.6	
Max aperture	F5.6	
Lens focal length	60.0 mm	
35mm equivalent focal length	90.0 mm	
Shutter speed	1/320 sec.	
F number	F9.0	
Exposure correction value	-0.3 EV	
Flash compensation	+0.0 EV	
Exposure program	Program AE(Auto Exposure)	
Metering mode	Multi segment	
ISO	400	
White balance settings	Shade (0)	
Flash	Used	
Flash mode	Forced flash	
Red-eye reduction	Off	
Saturation	Standard	
Contrast	Standard	
Sharpness	Standard	
Brightness	Standard	
Color space	AdobeRGB	
Creative Style	Vivid	
Scene selection		
Zone matching	Off	
Color temperature	5500K	
Magenta/Green compensat...	0	
D-Range Optimizer	Off	
High ISO NR	Normal	
Long Exposure NR	Off	
Super SteadyShot	On	

DOWNLOADING IMAGES

There are two main ways of getting digital files off the memory card and into your computer. One is to use an accessory card reader that downloads the files from your card. Another is to download images directly from the memory card in the camera using the USB cable included with your α500 or α550. Direct downloading eliminates the need to buy a card reader, but it means you have to get your cable and connect (and then disconnect) the camera to the computer each time you want to download. By contrast, a card reader simply remains connected to your computer and ready for use at all times. Also, downloading directly from the camera consumes a great deal of battery power, which is one argument for using optional AC Adapter AC-VQ900AM.

MEMORY CARD READERS

A memory card reader is a simple desktop device that plugs into your computer using either a FireWire or USB connection. Some models were designed to read one particular type of memory card while multi-card readers can accept several different formats. The latter can be useful if you use both SD/SDHC and Memory Stick PRO cards and especially if you also own another camera that uses a third type of card.

> **NOTE:** The α500 and α550 are fully compatible with SDHC memory cards; the HC means high capacity, up to 64GBs. However, older card readers were designed for use only with SD cards and do not do not accept the newer SDHC cards. If you buy SDHC cards, you will also need a card reader that is compatible with them.

‹ An increasing number of laptop computers are equipped with a built-in memory card reader, typically for the SD/SDHC format. Many of Sony's recent laptops include a card port for the various Memory Stick formats. Photo © Sony

> A memory card reader, compatible with SDHC or Memory Stick PRO cards, offers a quick/convenient method for transferring image data to a computer. Photo © SanDisk Corporation

After you have connected the card reader to your computer, put the memory card into the appropriate slot. The card should appear as an additional drive on Windows and Mac operating systems (for other operating systems you will probably have to install the drivers that come with the card reader). Select your files from the card reader and drag them to a preferred computer drive and folder. This process is the same as it is when the camera is connected to the computer, and is discussed in detail on pages 185-187.

PC CARD ADAPTERS

If you use a laptop computer it may have a built-in SD and/or Memory Stick card reader, making it simple and quick to transfer photos to the computer. Other laptops may have only a PC card reader; these require an SD-to-PC card adapter or a Memory Stick-to-PC card adapter. If you buy an adapter of this type, you can insert the memory card into that accessory; then, insert it into your laptop's PC card slot. The computer will recognize the memory card/adapter as a new drive, and then you can drag and drop images from the card to the desired folder in your computer's hard drive.

HINT: Most PC card adapters use the 16-bit standard, but several companies make 32-bit PC card adapters for SD/SDHC cards, sometimes called Cardbus 32 Adapters. These can take advantage of internal bus speeds that can be four to six times faster than 16-bit. The 32-bit SD-PC adapter costs three or four times more, but it is great when you have large image files to download to a laptop computer. If you consider buying this accessory, make sure that it is SDHC card compatible.

WORKING WITH IMAGES

184

DIRECT FROM THE CAMERA

Make sure to use either a fully charged battery or the optional Adapter AC-VQ900AM. Turn the camera on to make sure the [USB Connection] item in the ⚒ 2 menu is set for [Mass storage] (see page 183). Now, be sure to turn the camera off before taking the next steps.

NOTE: You must use a computer with a USB port and USB interface support. USB connectivity must be installed if your computer does not include it. Also, your PC must use Windows 2000 Professional or XP (SP3 or later) or Vista (SP2 or later); the Starter Editions and the XP 64-bit edition are not supported. If you use an Apple computer, it must have OS X 10.3, 10.4, 10.5 or a later version. If you own a computer with a Mac OS X operating system, you can download images from the camera but you will not be able to use the Sony Picture Motion Browser, because it is not Mac compatible. The Image Data Converter SR program is Mac compatible, however. For additional specifics about compatibility, check the latest information available at www. sony.net; after reaching that page, select your geographic area.

With the α500 or α550 is powered off, plug the supplied USB cable into the ⟵ terminal under the door in the left side of the camera. Plug the other end into your computer's USB port; to prevent possible problems, do not attach to a USB hub. Turn the camera on and look at the LCD monitor to confirm connection. From this point on, the process is the same if you were using a memory card reader instead of attaching the camera to the computer.

TRANSFERRING DATA

After the connection from the camera or the memory card reader has been made, an icon should also appear designating the device as a new drive, such as "Removable Disk (D:)." If the latter does not appear, disconnect the camera or card reader and start the process over.

The Picture Motion Browser software program should launch automatically with Windows based computers. You can then designate the folder in your computer where the images should be sent. With Mac computers—or if the Browser does not launch automatically with a Windows based PC—you will need to click on the DCIM folder and then on the folder (labeled as 100MSDCF) containing the images. (The "Misc" folder contains data that may be required for DPOF printing, discussed later in this chapter.)

You will then need to drag and drop the 100MSDCF folder—or individual images within that folder—to the desired folder in your computer. (To reveal the image files, double click on the 100MSDCF folder.) Do not change the names of any folder or file. To copy images, simply drag and drop the file icons to a location in your computer, such as "C: My Pictures." Be sure to specify Copy instead of Move. That will ensure that the image files will not be deleted from your memory card; this precaution will be useful in case there is some glitch with the data transfer.

CAUTION: Never disconnect the camera, remove the memory card, or switch to a different memory card while the camera's red access lamp is lit. If you do, data will be lost and the memory card may be permanently damaged. The same applies if you are using a memory card reader instead of the camera for data transfer to a computer. Also, do not format the memory card using the formatting option available with a computer; that can make the card incompatible with your camera. Format a memory card only with the Format item in the ▶ 1 menu.

A .jpg suffix indicates a JPEG image, which can be read and manipulated by nearly all imaging programs. The .arw suffix indicates a RAW format file consisting of raw data. You can download the .arw files, but later you'll need to use special software to convert them to JPEG, or (preferably) to TIFF. In addition to the Sony Image Data Converter SR, you can also use other ARW-compatible programs, such as Adobe Lightroom (a version higher than 2.5), Photoshop CS4, or Adobe Elements 6.0 (or later versions of each).

NOTE: If your copy of those versions of Adobe Photoshop or Elements does not support the ARW files generated by the α500 or α550, you will need to download from Adobe's website a newer version of the Adobe Camera Raw plug-in; be sure to install the plug-in exactly as specified by Adobe. If your Adobe Lightroom program is not compatible with the ARW files, you may need to download a newer version from the Adobe website.

^ The recent versions of Photoshop and Elements do support the ARW format files produced by the α500 and the α550 when used with the latest version of the Adobe Camera Raw plug-in.

After you have finished transferring all photos to the computer, the red access lamp on the back of the camera will go out. If you are using a memory card reader, the accessory's indicator lamp will be extinguished. Switch the camera off and disconnect the USB cable. If your Windows system requires that you first "Stop Mass Storage Device," be sure to follow the "Unplug" or "Eject" hardware protocol before unplugging the camera or switching to a new memory card. If using a Mac computer, drag the mass storage device icon for the camera into the trash. (A card reader can remain plugged in permanently unless you need to use the USB or Firewire port for some other device.)

CAUTION: Never disconnect the camera or insert/remove a memory card or switch to using another memory card in the camera while the orange access lamp on the back of the α500 or α550 is lit. The same applies if you are using a memory card reader accessory. If you were to do so, data might be lost and the memory card may be permanently damaged.

Although this may differ by geographic area, Sony often includes the following programs with the α500 and the α550:

BROWSERS

Picture Motion Browser—compatible only with the Windows operating systems listed on page 185—is a very basic and user-friendly program for browsing and organizing photos in your computer. The more advanced Image Data Lightbox SR—compatible with Windows and Mac operating systems—is preferable for comparing and organizing your images. It can display both JPEG and unconverted ARW files and provides filtering options to help you sort and later find images quickly. A full Help menu is available in Image Data Lightbox SR.

∧ The bundled Image Data Lightbox program is a versatile browser program and is fully compatible with Sony's ARW format.

IMAGE DATA CONVERTER

Compatible with both Windows and Mac operating systems, this program can be used to enhance ARW (RAW format) files and then covert them to JPEG or to TIFF. The converter program includes many tools. You can adjust brightness, contrast, hue, sharpness, curves, and white balance, set a desired D-Range Optimizer and Noise Reduction

level, change the Creative Style, and so on. Experiment with the various tools until you get the color and exposure adjusted to your liking before converting the ARW file.

Take care to avoid loss of important highlight or shadow detail. Set contrast, color saturation, and sharpness at fairly low levels because it's easy to boost these factors using image-editing software after you've converted from ARW; it's much more difficult to moderate or tone down excessively high levels.

∧ The Image Data Converter software is a great program for enhancing ARW format files and converting them to TIFF or JPEG.

After the enhancement is finished, convert and save your image file in an appropriate file folder in your computer. After you click Save As, select the 8-bit option unless you own a program (such as Photoshop CS4) with full support for 16-bit TIFF files. Be sure to give each image a unique name instead of using the more meaningless file name assigned by the camera. Afterwards, you can further fine-tune or manipulate the converted image using your image-processing software.

OTHER BROWSER SOFTWARE
Numerous third-party browser programs are available for organizing photos on your computer. They often include additional functions to help you manage your stored image files, such as the ability to search

for files, rename photos (either one at a time or in a batch), move image files to different storage locations, resize photos for emailing, create simple slideshows, and more.

Sony's Image Data Lightbox SR is certainly useful but some other browsers offer different features or more features for greater versatility. You can find programs of this type for purchase at retail stores or from the manufacturers' online e-stores. For example, the latest version of ACDSee, CompuPic, Digital PhotoPro, and BreezeBrowser offer a vast range of features.

An important function of a superior browser program is its ability to print customized index prints. You can then give a title to each of these index prints, and list additional information such as your name and address, as well as the photo's file location. The index print serves as a hardcopy that can be used for easy reference (and visual searches). You might want to include index prints with every backup CD or DVD you burn so you can quickly reference what is on the backup and easily find the file you need. A combination of uniquely labeled file folders on your hard drive, a browser program, and index prints will help you to maintain the quickest and most efficient way of finding and sorting images.

NOTE: Some browser programs may allow you to view the ARW format RAW files generated by the α500 and the α550, but they may not be able to convert the files to JPEG or TIFF. Do not attempt to open or to modify an ARW format file with any software that was not specifically designed for that purpose. Some of the more versatile image-editing software programs (such as the Adobe products mentioned) include browsers that are ARW-format compatible.

IMAGE CATALOGING

If you prefer not to use a browser program that organizes your image files, how can you edit and file your digital images so that they are accessible and easy to use? One way is to create specific folders for groups of images in your computer's hard drive. For example, in "C:MyPictures," you might create a variety of folders with titles like Vacation 2010, Jackie's Graduation, Cate's Birthday, and so on. Create new folders frequently for new events or new subject matter such as Trip to Epcot, or Dee Anne's Florida Birds. You can organize your photo folders alphabetically or by date inside a "parent" folder.

Before downloading any images to your computer, take a few minutes to review them on the camera's LCD monitor. Delete any that are obviously unacceptable, keeping those you want to look at more closely. After downloading these remaining photos, review them again on your computer monitor. Erase any additional images that you do not want in order to avoid squandering precious hard drive space.

Rename the images with descriptive file names. You will probably agree that "Josh_BDay_Candles.jpg" makes more sense as a file name than DSC0027.jpg, for example. Later, be sure to convert any JPEG files to TIFF before enhancing with image-editing software. Processing and resaving JPEG files in a computer can cause image degradation; that is also an argument for converting your ARW format RAW files to TIFF instead of to JPEG.

HINT: After shooting an event, you may want to set up one folder for the images: Bud and Cathy's Wedding, for example. After you adjust a photo using image-processing software, save it using a different file name. If the file name was "Kate_Bridesmaids_4.tif," for example, you might save the enhanced file as "Kate_Bridesmaids_4B.tif." This step will prevent overwriting of the original image so you can later return to it and try entirely different enhancing effects, or use more sophisticated image-processing software.

IMAGE EDITING PROGRAMS

Numerous programs are available for modifying images. As mentioned on page 186, some of these are also compatible with the ARW format files generated by the α500 or α550. A third-party program's RAW converter may include entirely different features than Image Data Converter SR, but it won't provide Sony's DRO or Creative Style options. Depending on the program, it may not provide the same quality after conversion as the Sony software. It is fine to use other programs to modify/convert RAW files, as long as the programs are fully compatible with the ARW format files.

You can use any brand of image-editing software to enhance an image that is in JPEG or TIFF format. Some programs have tools to perform advanced functions like cloning. Examples include the latest versions of Adobe Photoshop, Photoshop Elements, Adobe Photoshop Lightroom, Apple Aperture, Paint Shop Pro, Microsoft Digital Image Suite, or Ulead PhotoImpact, to name a few.

^ While some image-editing programs are expensive, some full-featured alternatives, such as Adobe Elements, are relatively affordable and offer a wide range of tools from basic to sophisticated.

NOTE: Check the software distributor's website frequently for updates to see if your imaging software supports the ARW (RAW format) files generated by your α500 or α550. Once you see it is supported, download and install the update to view, open, adjust, and convert ARW files.

IMAGE STORAGE

Although your images are stored as digital files, they can still be lost or destroyed without proper care. You will need a good back-up system. Many photographers use two hard drives, either adding a second one to the inside of the computer or using an external USB or FireWire drive. This allows them to easily back up photos on the second drive. It is very rare for two drives to fail at once.

However, it is recommended that you also burn your images to CDs or DVDs. Other alternatives such as zip discs, USB flash drives, and memory cards are certainly useful devices, but they are not ideal for long-term storage. Note too that the life of a hard drive is unknown, but hard drive failures can occur after a couple of years, not to mention accidental erasure. And a number of malicious computer viruses can wipe out image files from a hard drive (especially JPEGs).

The answer to these storage problems is optical media. A CD and/ or DVD-writer (or "burner") is a necessity for the digital photographer. DVDs can store about eight times the data that can be saved on a CD. Either option allows you to back up photo files and store images safely.

‹ When choosing a CD-R or DVD-R disc, select the archival type to minimize the risk of lost data over the years.

HINT: For long-term storage of images, only use R (not R-W) discs. The storage medium used for CD-R and DVD-R discs is more stable than rewriteable media such as RWs. If disc permanence is important, look for CD-R or DVD-R discs that are rated as archival such as the Mitsui Gold, the Kodak Gold, or Delkin Gold e-Film archival products.

VIDEO OUTPUT

The α500 and the α550 can also be connected to an HD television set, allowing you to show JPEG images to friends and family in a convenient manner. It is wise to use the optional AC Adapter instead of battery power if you plan to review your photos for any length of time. There is no need to specify which output standard or color system you want to use: NTSC (North America) or PAL (Europe and most other regions of the world). The camera will automatically make the setting suitable for the video device you are using.

Turn off the television as well as the camera. Insert one end of an optional HDMI (High Definition Multimedia Interface) cable—with Type C mini connector—into the camera's HDMI port. It's under the cover on the left side of the α500 or the α550. Then, insert the other end of the cable—with the larger connector—to a TV's HDMI input terminal. (That connection is usually on the side or the back of the TV set.)

> The camera can be connected to any brand of HD TV with an HDMI port using an optional cable. Recent Sony Bravia televisions offer extra features that can automatically enhance the photo display. Photo © Sony

NOTE: Sony does not provide any method for connecting the α500 or the α550 to a television's AV input jack. You may be able to find a suitable cable with a USB mini plug on one end and a so-called RCA plug on the other end. If so, you may be able to use that cable for connecting to a television without an HDMI input terminal. However, after extensive searching in my own geographic area, I was not able to find a cable of this type to fit the Sony cameras' mini USB port.

After making the HDMI connection, turn the TV on and select the video channel and the pertinent Output (such as HD or HDMI); check your television owner's manual or the on-screen Menu for guidance. Turn the camera on and press the F button. Images will be displayed on the TV instead of the LCD, as they would in conventional camera Playback ► mode. The camera's playback controls can handle all functions, except for the volume control.

You can view images with any brand of HD TV with HDMI connectivity. If you own a Sony Bravia television with VIDEO-A compatibility, the TV will automatically select the appropriate image quality level for viewing your photos. (With other TV brands, you may need to make several settings, including the resolution level.) You can use the [Link Menu] button on the TV's remote controller for options such as Slide Show, Single Image Playback, Image Index, and Delete. The α500 and the α550 are also compatible with Sony televisions' PhotoTV HD standard; thanks to automatic image enhancement by the TV, you'll get a remarkably detailed display of your photos.

NOTE: With other brands of TV's, the remote controller unit may not work properly when you are viewing images from the connected Sony camera. If that is a problem, set the **[CRTL FOR HDMI]** item to **[Off]** in the camera's 🔧 1 menu.

DIRECT PRINTING

You can also use the α500 or the α550 for direct printing JPEGs without using a computer. This feature is particularly simple with a printer that's equipped with a memory card slot. Some machines also include LCD screens that allow you to preview the effect that any of the printer's software will produce, such as cropping, red-eye fix, and Auto Fix. As an alternative, you can connect the camera to any PictBridge compatible photo printer using the USB cable provided with the camera. It works only with JPEGs in the sRGB Color space. (You can set the desired color space in the 📷 1 menu before taking photos.)

NOTE: PictBridge is a technology that allows for direct printing between a digital camera and printer as long as both are PictBridge compliant. The α500 and the α550 are PictBridge compatible, as are most Epson, Canon, and HP photo printers released since about 2004. Look for the PictBridge logo on the printer's box. Some photo printers also include slots for memory cards, allowing you to print JPEGs directly from the camera's memory card; this method does not require a PictBridge compliant printer.

‹ An increasing number of inkjet photo printers are equipped with slots for many types of memory cards. Nearly all such printers are also PictBridge compliant. Either feature allows for printing images without ever opening them in a computer. Photo © Canon USA Inc.

Start with a fully charged camera battery or use the optional AC Adapter. Make sure that the USB Connection item in the 🔧 2 menu is set to **[PTP]**. Turn the camera off and connect the USB cable from the camera to the printer. Then turn the camera on. The PictBridge screen will appear on the LCD monitor. Use the controller keys to scroll and

identify the image to be printed and to select the number of copies to be made. You can also activate or close the PictBridge menu using the camera's Menu button.

You can control the entire printing process using the controller keys to make an index print of all images on the memory card, select the paper size, layout and print quality, make printer setup changes, and so on. Finally, select Print>OK in the menu and press the controller's central AF button to proceed with the printing.

Direct printing will not give you the same results as printing from images that have been enhanced in a computer using image-editing software, because you have far fewer options to adjust image aspects such as color, contrast, brightness, and sharpening. The amount of control you have over the photo is limited entirely by the printer. Some printers do allow minimal image enhancement during direct printing, while others offer none at all.

DIGITAL PRINT ORDER FORMAT (DPOF)

Another printing feature of the α500 and the α550, DPOF stands for Digital Print Order Format. This allows you to decide which JPEG images to print before you actually do any printing. (RAW files cannot be identified for DPOF printing.) Then, if you have a DPOF compliant printer, it will print those selected JPEGs after you make the USB connection. The DPOF options are available in the [Specify Printing] item of ▶ 1 (see page 95) and include [Marked images], [All images], [Date imprint] On and Off, and [Cancel].

Use the Marked images option, scroll down to OK and press the AF button. You can now scroll through JPEGs on the memory card using the left/right keys of the four-way controller. When you reach a photo you will want to print, press the AF button. Now, DPOF 1 will appear over the image. If you want more than one print of that photo, press the AF button again; you can press it as many as nine times for nine prints of that photo. After you have finished marking JPEGs for DPOF printing, press the Menu button, scroll to OK, and press the AF button to confirm your decision.

OTHER PRINTING OPTIONS

Unless they own a fully equipped darkroom, photographers who still use 35mm cameras must leave their film at a photofinisher for processing and printing. After a period of time passes, they must return to the store to pick up the order. With digital photography, images can be printed immediately after taking the picture. There are multiple choices for printing. The following are most common:

Computer Download: After downloading images to a computer, use your own photo printer to make prints of any desired image.

Direct-Print Printers: Use a photo printer with a card reader (slots for memory cards) to make prints directly from the JPEGs on your card. Many such machines provide some control over exposure, color rendition, and cropping. Or, hook up your camera to a PictBridge compliant printer to make prints from the memory card in the camera.

Kiosks: Many stores offer self-service photo kiosks—just plug your memory card into the slot. Use the kiosk's controls to crop and enhance JPEG images from your memory card; specify the desired size and quantity.

Photofinishers and Mini-Labs: Most photo labs now have the capability to take your memory card and make prints or CDs from the image files.

Online Services: There are many photofinishers that offer their services through websites. Prices are reasonable and your prints are delivered by mail. Once you start an online album on a company's website, you can invite friends and relatives to view images and order prints.

Troubleshooting Guide

The Sony Alpha α500 and α550 are sophisticated cameras that provide reliable service. Although rare, a malfunction can occur as with any electronic device. And occasionally an inappropriate camera setting can lead to a technical problem. This chapter discusses those issues, the causes and solutions.

Note: Unlike some cameras, the α500 and the α550 do not include a reset button for use in case of some electronic malfunction. (The Reset item in the menu is strictly for resetting features to the factory-recommended defaults.) However, removing the battery (or unplugging the optional AC adapter) for 30 seconds achieves the same purpose. Do not remove the battery (or disconnect the AC adapter) when the red recording lamp on the camera back is lit; if you do so, the images may be corrupted and, in a worst-case scenario, the memory card may be damaged.

WARNING MESSAGES

When the camera encounters a specific problem, it will produce a warning message. When that occurs, follow the advice below. If that will not resolve the issue you may need to send the camera to an authorized service center.

Incompatible battery: You may be using a third-party battery said to be compatible with the camera or a battery designed for another camera. Some batteries look exactly the same but do not work in all cameras, even cameras from the same manufacturer. (Some unreputable retailers on the Web also sell counterfeit Sony batteries; these may or may not work and may or may not cause problems.) Switch to using a confirmed Sony brand NP-FM500H battery intended specifically for the α500 and α550.

Power insufficient: Charge the battery fully before attempting to use the sensor cleaning function.

Unable to use SD (or Unable to use Memory Stick) card: This usually indicates that the card was formatted in a computer; the camera's processor cannot work with that formatting. Scroll to OK and press the AF button. Format the card using the pertinent item in the menu. This will delete all data. (In this type of situation, you may not be able to recover any images on the card with third-party data recovery software.)

Reinsert SD (or Reinsert Memory Stick) card: There is a problem with the card; see above. Also try removing it and inserting it again. If that does not solve the problem, try gently cleaning the contacts on the card with a soft clean cloth.

SD memory card locked: The Lock switch on the side of an SD or SDHC card is in the Lock position; shift it to the other available position.

This Memory Stick is not supported: You are using a Memory Stick Pro made by another manufacturer and not fully Sony compatible or an incompatible Memory Stick. The camera supports only the PRO-Duo series of cards.

--E--: This may indicate a corrupt or malfunctioning memory card. Remove it and insert it again. Try the Format function in the ▶ 1 menu. Note that formatting will delete everything on the card. (You may be able to recover the images later using software such as the product from www.datarescue.com.) If formatting fails to solve the problem, replace the memory card.

No images: The camera cannot find any images on the memory card. It is possible that there are no images on the card; perhaps you have inserted a card that contains no images.

Processing: This indicates a delay after taking a photo with a 1-second or longer shutter speed when the Long Exposure Noise Reduction feature is on. The delay takes as long as the original exposure. (i.e. If the photo was made with a 15-second shutter speed, the extra processing takes 15 seconds; the camera cannot take another photo during this time.)

Unable to display: There may be images on the card but they were taken with another camera or were modified in a computer. Copy the images to a computer or a flash drive to save them; then, format the card using the pertinent item in the ▶ 1 menu.

Image protected: The camera will not let you delete a photo—or several photos—because they have been protected using the Protect item in the ▶ 1 menu. You can use that item to remove the protection from any image, using the procedure discussed on page 94. You can also quickly remove the Protection from all photos on the card, using the Cancel All option in the Protect item.

Camera overheating. Allow it to cool: When the camera is used in MF Check Live View, a thermometer symbol may appear instead. Either warning can occur after extensive use of Live View in a hot location or continuous shooting for a long period of time. Turn the camera off and wait at least a couple of minutes.

Camera error. System error: This warning should certainly lead you to remove the battery for at least 30 seconds. If that—or even longer battery removal—does not solve the problem, send the camera to an authorized service center.

WEB SUPPORT
Check the Sony Web site (www.sony.net and select your geographic area) occasionally for updates to firmware (in-camera software), new tips on problem solving, or information on company authorized service centers in your area. The following recommendations should solve most problems; however, if you experience camera malfunction—especially one that cannot be solved by removing the battery for 30 seconds—contact an authorized service center.

PROBLEM SOLVING

In addition to problems identified by error messages, you may encounter other difficulties such as the following:

PROBLEM	SOLUTION
Battery life is very short	Ensure that you are using a Sony brand battery and charging it fully. If shooting in low temperatures, warm the battery (under your coat or indoors) and try again. In other conditions, gently clean the battery terminals with a soft cloth. If the problem persists, the battery may need to be replaced.
Camera shuts down	Remember that the α500/α550 goes into sleep mode after a period of non-use, to conserve battery power. Touch the shutter release button to re-activate it.
Nothing is displayed on the LCD monitor	Touch the shutter release button to activate the camera's circuits. Press DISP button if necessary. Make sure nothing is near the camera's eye-piece activating the Eye-Start system; when the latter is active, the LCD display turns off automatically.
There are colored dots in the LCD display.	Ignore the dots since they will not be visible in the photos. If they are problematic, proceed with the pixel mapping function in the ✎ 3 menu, as described on page 102.
The viewfinder image is blacked out.	Make sure the camera is not set for Live View. If the lens cap is on the lens, remove it.
The camera will not take photos	You cannot take a photo while the flash is recycling (charging). Make sure the lens is mounted properly. Make sure a memory card is loaded. See if the memory card is full; delete some unwanted images or insert a new card. Remember, the camera will not fire if the autofocus system is unable to confirm focus, as discussed on page 113. Use manual focus if necessary. A warning about the memory card may be visible in the LCD screen as discussed earlier.
All of my menu settings and Function sub-menu settings were reset to the defaults.	This occurs when the battery is removed while the camera is On. Make the settings again; do not remove the battery when the camera is on except when a reset is required due to some electronic problem as discussed earlier, on page 199.
The five bars of the SteadyShot ▂▃▄▅ scale flash constantly even in bright light.	Some malfunction has occurred and the stabilizer is not active; you can take photos but the SteadyShot system will not compensate for camera shake. Try turning the camera on and off; if that fails, try removing the battery for 30 seconds.
The autofocus does not work.	Make sure the AF/MF switch on the camera—or on the lens if it is so equipped—is set to AF. If extremely close to your subject, try moving farther. In very dark conditions, the AF system may have difficulty finding focus; try manual focus. Note that AF does not work in the MF Check LV mode; switch to the Quick AF Live View mode by moving the switch (on the camera's right shoulder) to LV.

PROBLEM	SOLUTION
The flash does not work	Make sure the built-in unit is in the up position or that an accessory unit is ON. Make sure the camera is not set to the Flash Off mode on the mode dial or in the Function sub-menu. Remember that flash will not fire in bright conditions in certain operating modes as discussed on page 164; switch to another mode such as P and pop the flash up.
The bottom of flash photos are dark.	In close-focusing, the lens barrel can block some of the light from the built-in flash; move farther from the subject. Also try removing the lens hood since it may be blocking light.
Numerals in the viewfinder are blinking.	The scene may be too dark or too bright for a proper exposure at the selected settings. Try setting a different (aperture) f/stop or shutter speed until the blinking stops or try setting a different ISO level.
The ◄ and ► symbols in the viewfinder are flashing.	The scene is simply too dark or too bright for the camera to provide an accurate exposure. Set a higher ISO in dark locations or a lower ISO in bright locations. In very bright scenes, attach a neutral density or polarizing filter on the lens to reduce the amount of light reaching the sensor.
The images exhibit a strong color cast such as blue or amber.	This is usually due to an incorrect white balance setting in the Function submenu. Try the **AWB** option or the most suitable WB preset (such as Incandescent d when shooting without flash under household lamps). If those options do not solve the problem, use ⊾⊒ WB (see page 65.)
The corners of the image are dark.	Remove any filter you have placed on a wide angle lens and replace with a slim-ring filter. Never use more than one filter at a time. (Mild darkening of the corners is common with many zoom lenses but should not be visible if shooting at f/8 or a smaller aperture.)
An error message appears when trying to set Custom ⊾⊒ WB	Deactivate flash. If you do want to set ⊾⊒ WB for flash, activate flash but move farther away from the white target being used to calibrate the system.
The Live View display is not accurate re: exposure, White Balance, and depth of field.	This is standard in Quick AF Live View (set with the switch at LV) because the live preview is provided by a small secondary sensor and not by the image capture sensor. Switch to the MF Check LV mode for a more accurate display. Note however that the effect of any exposure compensation is not visible in either Live View mode but will be in the actual photo.
When viewing images on a computer monitor, some specks are visible.	This is probably dust on the CMOS sensor not removed by the automatic sensor cleaner. Proceed with sensor cleaning, using extreme care, as discussed on page 101.
The camera will not play back images	Make sure the LCD display is on; press the DISP button and press the ► button for Playback. If the camera is hooked to a computer with a USB cable, disconnect it. If a file folder name or the file names have been changed in a computer, images can no longer be displayed on the camera. Also, images made with another camera cannot be displayed.

Index

SONY α500/ α550 LCD (LARGE VIEW)

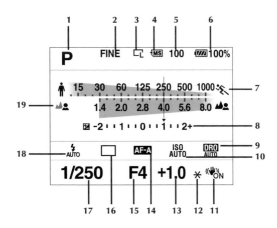

1. Exposure Mode	11. Steady Shot indicator
2. Image quality	12. AE lock
3. Image size	13. Exposure compensation
4. Memory card in use	14. Focus mode
5. Remaining number of recordable images	15. Aperture
6. Remaining battery capacity	16. Drive mode
7. Shutter speed effect indicator	17. Shutter speed
8. Exposure compensation indicator	18. Flash mode
9. D-Range Optimizer/Auto HDR	19. Aperture effect indicator
10. ISO (Sensitivity)	

Magic Lantern Guides®

Focusing: Set focus mode lever to AF or MF. For manual focus, use the lens' focusing ring. In AF, set desired items in the 🔲 sub-menu. Scroll to an item and press the AF button to confirm.

AF Mode:
AF-S (Single-shot AF): Press/hold shutter button to initiate and then lock focus while recomposing.
AF-A (Automatic AF): Switches from Single shot to Continuous if subject motion is detected.
AF-C (Continuous AF): Focus shifts continuously to track subject motion.

AF Area:
⠸ Wide AF area (9-point sensor): Camera automatically selects a suitable focus point.
⠸ Local AF area selection: When 🔲 sub-menu is not active, use multi-selector to select any single focus point. For instant center spot AF, press the AF button.
⬥ Spot AF area: Only central focus point will be active.

🙂 Face detection: Set On in 🔲 sub-menu. Available only when the camera is set for LV. Focus and exposure are optimized for faces in the scene.
⊙◦ Smile shutter: Also set in 🔲 sub-menu. Available only when the camera is set for LV and for Face detection. Camera fires automatically when a smile is detected. **Options:** Normal, Big, Small (the degree of smile that will trigger the camera).

Metering: Set metering pattern in the 🔲 sub-menu. Scroll to desired item and press AF button.

▣ Multi-segment: Evaluates scene brightness in 40 zones, or 1200 zones in Live View.
▣ Center Weighted: Averages scene brightness, but biases for a large central area.
▪ Spot: Measures small central area only.

Exposure Controls
ISO: Access with ISO button or 🔲 sub-menu. Scroll to desired setting; press 🔲 button; scroll to desired setting: press AF to confirm.
Exposure Comp.: Access with ⚹ button; scroll to desired level; press AF to confirm.
Flash Comp ⚡: Access in 🔲 sub-menu. Scroll to desired level; press AF button to confirm.
AE Lock: Press/hold AEL button to lock exposure value. When ▣ metering is used, constant light pressure on shutter release button also provides AE Lock.

Exposure Bracketing: Access with Drive ⊙/🔲 button or 🔲 sub-menu. Scroll left/right to set 0.3EV or 0.7EV increment compensation.
DRO: Access Dynamic Range Optimizer with D-RANGE button or 🔲 sub-menu. Scroll up/down to select Off or Auto 🔲; in Auto scroll right to set desired intensity level from 1 to 5.
HDR Auto: Access High Dynamic Range feature with D-RANGE button or 🔲 sub-menu when using JPEG capture. Scroll right to change from Auto 🔲 to a desired EV level from 1 to 5. (Camera will take two photos, at different EV levels, and merge them into one photo.)

SteadyShot (Stabilizer)
On by default; if using a tripod, turn off with SteadyShot item in 🔲 menu.
⠸: Denotes shutter speed is too long for stabilizer effectiveness. Set a faster shutter speed.
⊪: Denotes degree of stabilization in effect; if all bars are illuminated, stabilization may not be adequate.

White Balance: Access in 🔲 sub-menu; in all but AWB, scroll to the right to access additional options.
AWB: Automatic setting of White Balance.
Presets: Select desired item depending on the lighting condition; can set a + level for warmer rendition or a - level for cooler rendition.
Color Temperature: Set a desired Kelvin degree; scroll down and to the right/left to set Color filter (Magenta or Green) intensity.

Custom: Calibrate for accurate WB under unusual lighting conditions.

WB Bracketing: Access in Drive ⟳/◻ mode. Scroll left/right to select Hi or Lo variation level.

Essential Menu Items: Access with MENU button; scroll to a desired tab and then to any item. Press AF button, scroll to desired option, press AF to confirm.

Recording Menu ◻ 1
Set capture format, size/quality, and aspect ratio; set Flash control, Color Space, and SteadyShot Stabilizer On/Off.

Recording Menu ◻ 2
Set Long Exposure Noise Reduction On/Off and High ISO Noise Reduction High/Normal.

Custom Menu ✿ 1
Set Eye-Start, AEL button function, activate Grid Line, and Red-eye Reduction flash.

Playback Menu ▶ 1
Options for deleting & protecting images, formatting memory card, for slide show, DPOF printing, auto rotation of playback display.

Setup Menu ⚒ 1
Options for LCD brightness, date/time, power save time, HDMI control, language, and help guide.

Setup Menu ⚒ 2
Manage folders and files on memory cards, set USB connection type, and audio signal (beep) On/Off.

Setup Menu ⚒ 3
Activate cleaning mode, pixel mapping for LCD screen, check version of Firmware in use, and reset camera to all default settings.

Built-in flash range

At ISO	At f/4	At f/5.6
200	3.3 - 14 ft.	3.3 - 9.8 ft.
	1 - 4.3m	1 – 3m
400	3.3 - 20 ft.	3.3 - 14 ft.
	1 - 6m	1 - 4.3m
800	4.6 - 28 ft.	3.3 - 20 ft.
	1.4 - 8.6m	1 - 6m
1600	6.6 - 39 ft.	4.6 - 28 ft.
	2 - 12m	1.4 - 8.6m

Optimizing Features
Set a desired Creative Style mode in the 🔲 sub-menu. Scroll up/down among the Styles: ▣▣▣, ▣▣▣, ▣▣▣, ▣▣▣, or ▣▣▣ (Black &White). Scroll to the right from any Style to access levels control for contrast ◐, sharpness ⊡ and, except in B&W, color saturation ⬤. Press the AF button to confirm settings.

Live View
For a live, real-time preview of the subject on the variable-angle LCD screen. Select Quick AF (with LIVE VIEW, using the switch on the camera's right shoulder) for live preview with fast autofocus. Press the MF CHECK LV button for live preview with manual focus but with a superior and more accurate preview display.

Troubleshooting
Camera does not work: Check the AF/MF switch; if battery; ensure that lens is properly mounted; insert a memory card and set switch for the correct card type; format card in ⚒ 1 menu. If necessary, remove battery for 30 seconds.

Autofocus does not work: Check the AF/MF switch; if extremely close to your subject, try moving farther; in very dark conditions, the AF system may have difficulty so try manual focus. AF not available in MF CHECK LV mode; switch to the Quick AF Live View (LV) mode.

No data in LCD monitor: Touch shutter release button to switch from power saving mode; press DISP button to change display mode; ensure that eye detection sensor is not blocked.

Flash won't fire: In some Scene modes, flash fires only in dark locations; in P, A, S, or M mode pop flash into the up position. Make sure the camera is not set to the Flash Off mode on the mode dial or the 🔲 sub-menu. Ensure that accessory flash is On and batteries are charged.

Photos are dark: Underexposure of a light-toned subject is possible; set +1 ⊡ compensation and try again. Reset ⊡ zero in normal conditions.

Flash photos are too dark: Move closer to the subject; set a higher ISO level. If you are close to the subject, set +1 flash exposure compensation (⊞ in the 🔲 sub-menu.) Reset ⊞ to zero afterwards.

©Lark Books, www.larkbooks.com